D1538235

NOT ADDED BY
UNIVERSITY OF MICHIGAN LIBRARY

刘小东 Liu Xiaodong
Weight of Insomnia
失眠的重量

刘小东 Liu Xiaodong
Weight of Insomnia
失眠的重量

如何 优雅的 转动. 不确定,

不一定

搬家

② 2015. 2. 23

②

2015.2.23

③ 不一定，不确定

不一定

大三 2015.2.23

少年取灯

两棵树

FEBRUARY 24, 2015: Old man cutting wood, old man cutting trees

猪头和鸡

2015.2.24

术问 — 真实的回归
Datumsoria: The Return of the Real
Zhang Ga 张尕

艺术（一个适用于旧体制的旧词）与物质世界中的感官感受其实只有象征式的关系；相反地，创作媒介则与物质世界有很大的关联，而这与物质性紧扣的关系使它们得以在「真实」本身里运作。
— 弗莱德里希·基特勒（Friedrich Kittler）〔注脚 1〕

白南准在1993年创作的机器人雕塑《成吉思汗的复兴》（The Rehabilitation of Genghis-Khan）中所展露的图景并非是对未来的展望，而是一种验证和认可。同年，通过首个能显示图片的网页浏览器Mosaic 1.0〔注脚 2〕，人类的电子足迹终于第一次透过机器网络中的突触踏上讨论已久的信息超高速公路。从那时起，历史开始了新的路径。白南准向世人宣告的世界图景是纯粹海德格尔式的 — 世界已经变成了一幅图像，并且是一幅电子图像。

白南准那经改头换面的成吉思汗大汗不再从马背上威武地发号施令，而是风趣逗乐地踩着自行车。一代帝王头戴潜水头盔，躯干是由一台加油机改造而来的拼接物，其双臂则由两根塑料管充当。他的坐骑显得负重累累，后座上叠置着满满当当的一堆电视机壳，里头可见由霓虹灯管制成的符号和字符，暗示着编码讯息经由电子路径得以传输；一块嵌入到加油器中空部位的荧幕播放着录像，从人们司空见惯的物件渐变到象征着古代荣耀的金字塔。

"The arts (to employ an old word for an old institution) entertain only symbolic relation with the sensory fields they take for granted. On the contrary, media relate to the materiality with-and on-which they operate in the Real itself." Friedrich Kittler (ENDNOTE 1)

Nam June Paik's robot sculpture *The Rehabilitation of Genghis Khan* (1993) revealed not so much an image of the future as a substantiation and validation of such visions. This was the same year in which the much discussed 'information superhighway' finally arrived via the first web browser, Mosaic 1.0, logging electronic footprints of human traffic through the synapses of machine networks. From then on, history took a new path. What Paik made public was a world picture in the genuine Heideggerian sense: the world had become a picture, and an electronic one at that.

Paik's *Genghis Khan* transposed the marauding emperor (in tongue-in-cheek fashion) from majestic commander upon horseback to an amusing pedalling bicyclist. Topped by a diving helmet, the prince's torso is a patchwork made from a petrol pump conjoined by plastic pipe limbs. Loaded in the back of his overburdened vehicle is a pile of television cases stacked on top of each other encasing symbols, characters made of neon lights, intimating the transmission of encrypted messages through an electronic pathway. A screen that is embedded inside a hollowed-out part of the fuel dispenser displays video images that morph from mundane objects to a pyramid of ancient glory. (CONTINUES)

Nam June Paik, *The Rehabilitation of Genghis Khan,* 1993, TV monitor, 10 TV cases, diving helmet, neon tube, bicycle, fuel dispenser, plastic pipes, clothes, 1-channel silent video in colour, 217×110×211cm

白南准，《成吉思汗的复兴》，1993年，电视荧幕、十个电视机壳、潜水头盔、霓虹灯管、自行车、加油机、塑料管、衣服、单频道无声彩色影片，217厘米×110厘米×211厘米

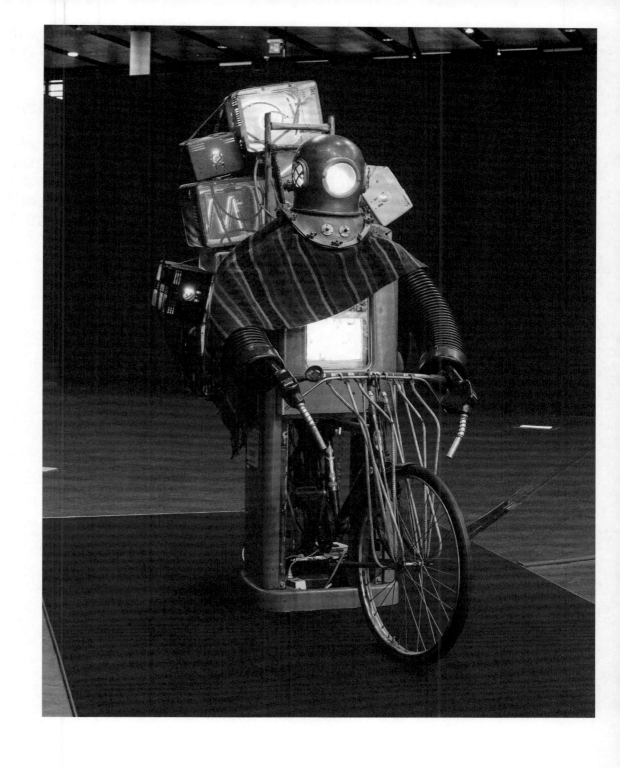

〔续〕这位世界征服者只身从昔日的高速通道 — 丝绸之路 — 踏入二十世纪的信息超高速公路，赖以统治世界的不再是马背上的策略，而是通过光纤传输的即时数据，以数据包中的比特与字节为单位，诱发距离的崩塌与多重时间的并置 — 这就是这位世界征服者的「复兴」。

白南准似乎是对浪漫过往充满怀旧心绪的一代 — 他这件作品呈现出人类与机器的连结，与其所促成的一种和谐新世界秩序。就这样，成吉思汗于这个所谓全球共享的电子时代恢复他过往的光荣。与之相较，成长于八十年代动荡变迁中的画家刘小东在呈现他的视角时，态度则显然不那么欢欣鼓舞。刘小东的写实派画作尽管是充满感染力的具象画面，却脱离了法国库尔贝（Gustave Courbet）与俄国列宾（Ilya Repin）传统中时常出现的戏剧化姿态与寓意指涉。刘小东画布上的人物或道具并非图解或象征符号，而是事件运行轨迹所留下的记录与证据。他的笔触涂抹表现出对象鲜活的内在 — 步入尴尬中年的童年玩伴；被迫搬迁的租客；浑身是煤灰，带着疲惫微笑的矿工；某家伦敦酒吧里的喝酒伴。他描绘那些在委约创作或自发的田野写生中交上的朋友。他不仅用颜料，也以摄影和日记记录着日常琐事。他所追寻的，是真实。

The 'rehabilitation' of this world conqueror sees him departing from the rugged route of the Silk Road, the expressway of his day, and instead being bootstrapped to the superhighway of the 20th century. World domination on horseback gives way to instantaneous data transmission through optical fibres in packets of bits and bytes, inducing the collapse of distance and the simultaneous juxtaposition of multitudinous times.

If Paik's work hails from a generation reminiscent of a romantic past, calling for the lost glories of Khan to be resurrected in the global village of the electronic era—through the liaison of humans and machines in order to joyfully procure a harmonious new world order—then Liu Xiaodong, a painter coming of age in the aftermath of the turbulent vicissitude of the 1980s, has apparently attained a somewhat less joyous deportment in rendering his vision of art. As figurative and evocative as they are, Liu's realistic pictures look removed from the histrionic gesticulation and allegorical directives often associated with the tradition of Social Realism, such as Gustave Courbet from the French lineage or Ilya Repin of Russia. Liu's documentary-style canvases do not illustrate, nor do his figures and props symbolize. Instead they are records of immediacy, evidences that trace trajectories of events as they unfold. His brushstrokes bring his subjects viscerally to life: whether they be former childhood playmates now in middle-aged awkwardness; tenants dislocated from their homesteads; miners cloaked in dust with fatigued smiles; or a few drinking pals in a certain London pub. He paints those he has befriended during his live painting assignments, sometimes commissioned, at other times of his own volition. He inventories the routine and the mundane not only in oil, but also in photographs and diaries whenever he is on a field trip. Liu searches for the real. (CONTINUES)

〔续〕刘小东的写生作品显现出他对真实的追寻保持着某种对表象性真实的回避；有时这个对真实的追寻反而会以出人意料的方式在迂回与捷径中展开。他最新的创作《失眠的重量》（2015年至2018年）恰恰表现出这一裂变。经过一段持续的合作，刘小东与技术团队进行了密集的实验并开发出一套自动化系统，使用流媒体数据和不同的电脑视觉演算法，在三个月的展期内持续进行绘画创作。具有表演性的自动化绘画在让人感到陌生的同时又引人入胜。

曾在上海新时线媒体艺术中心展出的该项目的第一批作品中，艺术家精心选择了三个地点并架设了镜头：在上海标志性的外滩，行人、汽车、公交车与自行车争先恐后地穿过马路；在北京时尚街区三里屯的十字路口，老练的城里人与新来的外地人摩肩接踵；在艺术家家乡的一处广场上，第三个镜头凝视着业已萧条的老工业城市，不论是黎明或是黄昏，成群结队来健身的老年人让这个广场热闹非凡，他们随着迪斯科的节奏起舞，自娱自乐地扭动腰肢，颇有民俗风情。所有这些人群的活动轨迹与其他类型的存在体 — 公交车、汽车、树和那些无法辨认的物体 — 所留下的痕迹全部被转化成连续的数据包，不再具有任何具体的物质特性，就好像真实要先经历一个脱离物质的过程，从而变得非真实且泛化，才能使第二阶序的真实出现。由此可见，泛化正是新现实的起源。

In his live paintings, Liu Xiaodong's search for the real gains ground by a degree of retreat from the real as it appears and it sometimes takes surprising detours or shortcuts. His most recent project *Weight of Insomnia* (2015-2018) is precisely such a rupture. Working assiduously with a group of technologists over an extended period of experimentation, Liu has developed an automated system that uses streaming data and computer vision algorithms to continually paint a canvas for the entire duration of a three-month-long exhibition. The autonomous and performative painting is simultaneously defamiliarizing and engrossing.

For the first iteration of this project at Chronus Art Center three original locations were carefully identified and equipped with video cameras: one near the iconic Bund in Shanghai where humans, cars, buses and bicycles vie with each other to cross the street; another monitors a crossroad in Beijing's fashionable Sanlitun district where urban sophisticates rub shoulders with novices from the provinces; and a third camera watches a public plaza in the artist's home town, a dilapidated former industrial city. At dawn or at dusk, this plaza is often enlivened by troupes of elderly people dancing to disco tracks or participating in aerobic drills. All these human trails and traces of beings of other types—buses, cars, trees, and indistinguishable objects—are turned into a continuum of data packets indifferent to any specific material property, as if the real must first be stripped of all substance, thus becoming unreal and generic in order for the real of the second order to emerge. The generic is thus the genesis of a new reality. (CONTINUES)

〔续〕三块三米乘二点五米的巨型画布被安装在粗陋的施工脚手架上，抖动的画笔由机器控制，将镜头抓取到的断断续续的数据转译为建筑物与交通工具的轮廓、婆娑树影与重重人影。如果说写生的要义在于捕捉一个飞逝的瞬间，定格於一个过去的时刻以寄情言志，那么刘小东画布所描绘的事物则处于永恒波动的多重瞬间。在这多重瞬间里，每一刻都有新的沉淀物产生，它们由物质堆积而成，彼此重叠、并置、连结并截断，情感亦随之潜入。在这连续进行的过程中，我们要先把真实的地理地点转化为非真实的二进制数据包，才能有机会重新诠释「真实」 — 这个「真实」有分身术，是起点，也是终点。作品里最终的图像是轨迹所形成的网络，它们不断地增厚、凝结，最后形成富有张力的画面，仿佛是波洛克（Jackson Pollock）的抽象与弗朗兹•克莱恩（Franz Kline）的动作表达合二为一所产生的升华效果。这并不表示说抽象是一个减略或具体化的过程；抽象也不一定要有表現性 — 事实是，这种抽象来自电脑处理海量资讯时發生的重置与重复。

艺术家在此仿佛成为机器意识的化身，抑或机器获得了知觉能力，开始了一场与无尽失眠的博弈，将那无可名状的欲望与焦虑，人与机器间飘逸的梦魇和升华相互交织成一幅不断展开的拼图。在多重已逝去的时间并置之时，不同的距离被压扁为像素平面，它具有世界图像的症候，交织着瞬时性与同时性，重复增生出抽象与泛型的差异。刘小东不仅在这个互联网和演算法时代把绘画这个创作媒介重新定位，同时还揭示了一种新的现实 — 这种现实存在于由流动数据引导的创作媒介的物质性中。在这个新世界中，「真实」不断地进行相位移动，我们需要新的方式传达情感状态。

Three large-scale canvases, each three by two-and-a-half metres, are mounted on crude construction scaffolds. A robotically controlled paintbrush jitteringly translates the discrete, incoming datum captured by the video cameras into contours of buildings, silhouettes of trees, outlines of vehicles, and shadows of human figures. If the canon of live painting is to arrest a fleeing second, to fixate a bygone moment for rumination on signification, what Liu's canvases depict are a multiplicity of instants that are forever fluctuating, generating at each moment a new sediment of material accretion, overlapped, juxtaposed, concatenated and truncated. In this continuous process the reality of any geographical locality has to first become the unreality of binary data packets in order to reinvent the real that doubles as origin and destination. The resulting image is a network of trails thickened into a congealed surface tension reminiscent of a Jackson Pollock abstraction heightened by a Franz Kline action, yet against the logics of both abstraction as reduction or as performativity as embodiment: information overload creates abstraction in reversal and repetition.

It is as if the artist, reincarnated in a robotic consciousness, or the robot having acquired a sentient capacity, wrestles through an endless, restless insomnia to piece together an ever-evolving jigsaw of amorphous desires and anxieties, fleeting nightmares and ruptures of machines and humans alike. In the juxtaposition of multiple times elapsed, distances are flattened into a pixelated horizontality symptomatic of the world image of instantaneity and simultaneity, of difference propagated by repetition, of abstraction and genericity. Liu thus constructs a new awareness of contemporaneity. In so doing, the artist not only re-assesses painting in the age of the internet and the algorithm but also makes apparent a new reality that situates itself in the materiality of media informed by data flux. In these perpetual phase-shifts of genesis, emotion acquires a new interpretation. (CONTINUES)

〔续〕也许有需要发明一个能具体描述这件事情的新术语……我们将其称之为「术问」（datumsoria）吧！「术问」这一新词由「数据」（datum）与「感觉中枢」（sensoria）合成而来，指代内在于信息时代的新感知空间 — 它显现了新的真实逻辑，这一现实是基于由1与0的泛型所构成的二进制脉冲的虚拟力量，形状与形式从泛型的内在性平面中涌现并实体化。真实，既不是在表象过程中产生的一种效应，也没有超现实的含义；真实，原来是被掩饰的虚拟性。真实是作为生成性的泛化 — 它是涌现或是创造的原理。

白南准曾期待一个具有家族忠诚感，通情达理的生化人与人形机器人与人类共生的未来〔注脚3〕。 只不过他的机器人仅仅是浪漫的标示牌或者是尚未兑现的真实的象征性姿态。通过沉淀感知的痕迹，激发情感的潜能，在《失眠的重量》颠覆性的数据流中诞生了技术自主生成的意识，它具有另一阶序的主体性，而且要追问另一维度中新的伦理，正如已故的媒体理论家弗莱德里希·基特勒在开篇引文中所道那般。

毫无疑问，「术问」阐明了我们这个星球是如何被一层膜状的网络系统包围着，这一层膜将我们在工作与闲暇的习惯上及政治与经济的准则上都产生了不可逆转的改变；「术问」暗示了所谓真实现在已不仅仅存在于物质世界 —肉体与社交场合— 的交流；「术问」更提醒了我们要去留意谁是这个新的真实的主人 — 他们正在以比特、字节和演算法在这数码世界扩展势力。

Perhaps a new descriptive register may be invented. Let's call it *datumsoria*, a neologism concocted from datum and sensoria. Datumsoria denotes a new perceptual space immanent to the information age. It bespeaks the logic of the new real, a reality predicated on the virtual force of the binary impulse, of the genericity of ones and zeros from whose plane of immanence comes forth of a hardening of shapes and forms. The real, against all odds of the real as an effect of representation or the real as the surreal, is virtuality disguised; the real is the generic as the generative, it is the principle of emergence or of creation.

Nam June Paik had looked forward to a future of man-machine symbiosis in performative cyborgs and conscientious humanoids with familial loyalty. (ENDNOTE 2) If only his robots were romantic signposts and symbolic gestures of what was yet to come. Precipitating sentient residues and invoking emotive potentials, there emerges, in the disruptive flux of *Weight of Insomnia*, a consciousness of technical autopoiesis that is capable of subjectivity of another order as intuited by the late Friedrich Kittler in the opening quote.

Datumsoria attests, unmistakably, to the formidable presence of a planetary membrane of the network that has forever changed the rules of the game in work and play, in politics and economics. Datumsoria also signals that the politics of the real no longer only lies in the sphere of actual bodies and social sites, but also alludes to the ownership of this new reality, which is constructed through bits, bytes, and the algorithmic power of the digital.

张尕是一位媒体艺术策展人，现受聘于中央美术学院艺术与科技中心，担任特聘教授及主任。他还是中国首家致力于媒体艺术的非营利性艺术机构 — 上海新时线媒体艺术中心 — 的总监。曾任纽约帕森斯设计学院「媒体艺术」科的副教授，并在麻省理工学院媒体实验室及斯坦福大学担任过一些客席职位。2008 年至2014 年间，他于中国美术馆策划了国际媒体艺术三年展系列，其中包括「齐物等观」（2014年）、「延展生命」（2011年）及「合成时代」（北京奥运文化项目，2008年）。近期主要策展项目包括「机器不孤单」（广州三年展（2018年）、「『非』真实 — 算法之当下」（瑞士巴塞尔电子艺术中心, 2017年）及「术问 — 真实的回归」（德国卡尔斯鲁厄媒体与艺术中心, 2017年）。

〔注脚 1〕 弗莱德里希•基特勒著，科技世界的真相 — 存在性的系谱学（*The Truth of the Technological World: Essays on the Genealogy of Presence*），埃里克•巴特勒（Erik Butler）译，斯坦福大学出版社，2013年的電子書版本。

〔注脚 2〕 1993年美国伊利诺伊大学的国家超级电脑应用中心（ NCSA ）发布的Mosaic 1.0是首个在普通用户中大受欢迎的网页浏览器，九十年代早期绝大多数的网页是文本，Mosaic点燃了互联网的火种，使其迅速发展为我们现在所熟悉的面貌。请参考www.wired.com/2010/04/0422mosaic-web-browser/

〔注脚 3〕 白南准在1985年相继创作了《机器人家族》系列，以表达家庭单位与科技发展之间温和的关系。作品复制了大家族的层级结构：母亲、父亲、孩子、祖母、祖父、阿姨和叔叔。在白南准的成长经历中，这一结构内在于韩国传统中。请参考《白南准：成为机器人》，亚洲协会美术馆，2014年。

Zhang Ga is a media art curator. He is Distinguished Professor and Director of the Center for Art and Technology at China Central Academy of Fine Arts. He also directs Chronus Art Center in Shanghai - China's first non-profit art organization dedicated to media art. Previously, he was Associate Professor of Media Art at Parsons School of Design and has held visiting positions at various institutions including the MIT Media Lab and Stanford University. From 2008–2014, he curated the widely acclaimed international media art triennial series including 'Synthetic Times' (A Beijing Olympics Cultural Project); 'Translife' (2011), and 'thingworld' (2014) at the National Art Museum of China. His recent curatorial projects include 'Machines are Not Alone', Guangzhou Triennial (2018); 'unREAL: The Algorithmic Present' at HeK Basel (2017) and 'Datumsoria: The Return of the Real' at ZKM (2017).

(ENDNOTE 1) Friedrich Kittler, trans. Erik Butler, *The Truth of the Technological World: Essays on the Genealogy of Presence* (Stanford: Stanford University Press, 2013), Kindle edition.

(ENDNOTE 2) Beginning in 1985, Paik introduced his *Family of Robot* series that replicated the extended family hierarchy of mother, father, baby, grandmother, grandfather, aunt and uncle, a structure intrinsic to Paik's traditional Korean upbringing. See Nam June Paik: *Becoming Robot*, Asia Society Museum, 2014

2015. 3. 8

晚11点了，在园景酒吧和Jerome谈完威尼斯个展，又与张尕及他的小组李可、方可，也还有杨波聊多媒体项目。

前几个月张尕动我私说了让我做个新的异想天开的项目。我说我和我最想做的就是测量忧伤的重量。忧伤时你确能到体内有种象水银一样的东西随着你的辗转反侧而慢之况在你的身体靠在床的那面。忧伤是有重量的。他说这是好主意，他说想让我以艺术家的想象力去做的从未做过的东西。让一个画家做全新的艺术是有意义的。后来他回美国，我又和李可方可谈此事，他们说也许能做但操作很难，得测量多少人呢，如何在他们忧伤的

MARCH 8, 2015: At 11pm I finished discussing the Venice solo show with Jerome [Sans] at Parkside Bar, then I spoke with Zhang Ga and his team, Li Ke and Fang Ke, about a new media project. Yang Bo was also there.

A few months back, Zhang Ga contacted me and talked about the possibility of doing a completely unprecedented new media project. I said what I would most want to do is to gauge the weight of sadness. When we are sad we definitely feel something inside—something that feels like quicksilver that with one's tossing and turning slowly sinks to the side of the body lying down on the bed. Sadness has a weight. He said that it's a good idea, he wants to use my artist's imagination to do something unprecedented. To make a painter create a completely new type of art is very meaningful. After this, he went back to the States but I later met with Li Ke and Fang Ke to continue discussing this matter. They said that it might be possible, but implementing it could be difficult: how many people would you want to measure, how can you be sure to find them at the moment when they are sad? After that I thought it might be too preposterous of an idea, so I began to think of developing this influence, through things [drawings] such as *Young Man taking the light, How to elegantly turn around*, these sort of movements, things that any person in film post-production could do which would also carry on my technique of painting.

时候我和他们？在美术也觉得荒唐，从开始绝影像上发展，比如"少年取灯"，"如何优雅地健身"等等，这些好操作，找电影后期高手就了实现，又延续了我自己以视角。⊕

这次张尕来，我给他看了这些想法草图，他说今天以前沿思想是主体与客体以一致性，同等就是不同种族以人对于宇宙来计画就是一个人，都是客体，人和物是平等以。他反对我寄托想象征性以视觉影像，要脱离影像，做重来不曾做过以东西。他说这是最初以想法最好，——忧伤以重量—— 这种思路是有意思以。我说难在操作性，他说你别管操作以事，可以找科学家操作。我说我总是想把精神变成物质，精神是看不见以，但她纪了物，她支配一切，但我不是

The next time Zhang Ga visited me, I gave him some sketches and drafts I had made of my ideas.
He says that today the most pioneering ideas are about the homogeneity between subject and object,
for example how different ethnicities of people describe the universe as a singularity, everything
is subject, the balance between man and matter.

He contradicted the perceptual images of symbolism I rely on. I need to break free of image
and do something I've never done before. He said my initial idea was the best: the weight of
sadness. This way of thinking is very interesting. I said that the difficulty with that is in
making it operational, he said I shouldn't worry about these sorts of issues, that he would find
programmers and engineers to make it viable. I said that I've always thought about turning spirit
into material, the spirit is invisible but quite frightening, dominating everything but I'm still
not convinced. I want to try and find out what kind of a thing a spirit ultimately is.
Can it be quantified, and if it can be quantified, then the robotic can truly control mankind.
He said that's correct, robots can definitely control human beings.

不顺气，总想到比精神多之外在是什么东西，比不准量化，如果能量化，机器人就比真正接触到人类了。何况对，机器人一定会接触到人类。

好了怕，让我们先换想这个结果，做一些去做美强。

人类会有这一天。

简单地讲人与动物一样，进而与植物一样，再进而与物体一样，人是物质，人是物体，进而才在更大以关怀。

是呀，看之就不比话或两个刘小东。其实本来画之以最根本原则是我用物质组成以视网膜触摸猫电所各到以物质世界，从而精神以力量。但精神仍竟是最可怕以力量。战胜它我们才能天人合一，幸福享乐物体以本质。

偏雨与陈晓薇闲聊。她说美国有这种实验：当画家和非画家站在同一幅画前。眼睛的视线转移是不同的。非画家的眼电波是混乱的，画家的眼电波是专注一的。

非画家

画家

也个实验启发了我。可用热波态力去呈现忧伤的重量

15.9.19

SEPTEMBER 19, 2015: Once in a while I talk to Chen Xiaowei, whenever she has shows in Shanghai. She said that in the US there have been these sorts of experiments. When a painter and a non-painter stand in front of the same paintings, the line of sight their eyes follow is different. The non-painter's sight is confused and goes all over the place, the painter is more focused.

Non-painter

Painter

This experiment inspires me. Maybe I can use thermal waves to try and reveal the weight of sadness.

排
队
人

杨 15.9.19

SEPTEMBER 19, 2015

19/09/15
frlo Segrera

2015. 9. 20
昨天 ~~CAC~~ 的 Fito 从上海来到我作室
专程来谈我的 ~~重量~~ "悲伤的重量"

她从画家和 ~~非画家~~ 看同一幅画时
的视线不同的轨迹，来推策我的作品
构思在展厅造两间房子、观众分别
进入两个房间，（一间陈旧的没落，
一间豪华美好）
将每个的轨迹〔下〕
星星在一大屏幕上，我是试来找到
最后无法承载 留下来，形成悲伤的
曲瓜线。

Fito说也可以让观众在展厅
外形成在屏幕上形成点，越积越多。

SEPTEMBER 20, 2015: Yesterday Fito Segrera from CAC came to the studio from Shanghai.
He came up especially to talk about my *Weight of Sadness* idea.

A painter and a non-painter both look at the same painting but their eyesight follows different
paths – I thought about making a work that would be compose of two small rooms built inside the
exhibition space. One room that is completely outdated and falling apart, the second room to
be fitted out luxuriously. The audience will separately go into the two rooms, and the path they
follow through the space will be displayed on a screen, with more dots [from movement] that
accumulate meaning, that in the end the burden will be unbearable and it will start to drip
down to form the arc of sadness.

太实好了。我们在世界各地选择
八个地点，摆上机器。将人物转化
我抽象m点投射在厅屏幕上。
不，最好是用机器手画下这些点，
画在纸上。
　　节省
　为滚辣成本　~~国画最大线~~，还是
选择四个地点就好了。一是叙利亚
　　　华盛顿
难民，二是~~国~~白宫，三是自然美景，
四是现场大街。

　　我立刻微信喊叫张尕，告诉他
我们m美妙m结局，他说很好，也飞好迎
延续了我m意识那李全球化m思路轨迹。
我说你终于把我逼疯了。

Fito says that we could also have the viewers outside of the exhibition space turning
into dots on the screen: the more focused their position is, the more dots will appear.
That's great, we'll choose eight locations around the world and place the machines there
which will turn human beings into abstract dots shot onto the screen in the exhibition hall.
No, actually it's even better if there could be a machine to paint these dots: paint on paper.

In order to cut costs, maybe only four locations would be better. One related to the Syrian
refugees, the second at the White House, the third in a beautiful natural landscape and the
fourth as a street scene.

I sent a WeChat message to Zhang Ga right away telling him of our wonderful result. He says it's
very good, it also continues in the same vein as my own thought process of following the trails
of globalization. I said that he has finally driven me crazy.

全靠每天二十四小时扫不停的新闻、社交媒体、无处不在的闭路电视与围着地球转圈的人造卫星，我们比从前所有人类都看得更多、更远，而这就是当今世代最具代表性的生活特征。方便是方便，但对某一撮人来说其实是颇为困扰的。面对这眼前变化多端的世界，以及一大堆汹涌而至的资讯，我们不习惯独立思考，认为自己没有可能影响任何事物，少不免会有强烈的无助感。难怪我们都被愤怒或冷淡的情绪所吞没，以致只能于抗议行为与无奈退隐其中二选一。即使我们只希望陷入没有好梦的睡眠状态，也是徒劳无功。因为刺眼的街灯、嘈吵的交通、发光的屏幕及电子产品叮叮作响的提示，都令疲累不堪的人们无法以睡眠作为最后能够投靠的避难所。作家乔纳森·克拉里（Jonathan Crary）曾在著作《24/7：晚期资本主义与睡眠的终结》（24/7: Late Capitalism and the Ends of Sleep）中提到，睡眠是人类体验中最不被社会制度剥削及最不受拘束的，然而各方面的管制系统及商业贸易正在对这和平的空间展开攻势。唯一有能力去颠覆上述压力的人是失眠症患者。虽然在漫漫长夜裡饱受煎熬、焦躁不安，但他们仍能在不能入睡的时候保持高度意识。作者克拉里对失眠症还有以下的叙述：「我们身处这多灾多难的世代，要面对，就要思考个人责任。过程困难重重，我们要好好把握失眠这个沉思的好时机。」〔注脚 1〕

失眠人凝望着黑夜 — 社会中各种各样的暴力开始在他眼前呈现。虽说他是无助的受害者之一，但他岂能置身事外？每一个人都是这暴力的一部份。失眠带来的重量一直压着刘小东，但慢慢地这种重量变成了他创作时的重心。对这位艺术家来说，失眠是焦虑的产物；焦虑来自对世界的关心。社会超速发展，加上政府政策对老百姓日常生活的干预，忧郁亦因此产生。社会鼓吹不停的劳动，体力透支之后的睡眠好像是唯一的出路，而失眠彷佛成了一种坚持 — 对这层层迫压的一种抗衡。当大家都进入了睡眠模式，失眠人的双重身份便随即启动。他们关不了机，一边忍耐这看夜更的寂寞，一边半梦半醒地于黑夜中寻找答案。

The most signal characteristic of our modern age is the extent of our vision. Aided by 24/7 rolling news and social media, pervasive surveillance cameras and orbiting satellites, we see ever further, constantly assailed by images of scale and distance. Yet without the corresponding agency to effect the world as it is presented to us, our ability to enact change seems ever more reduced. No wonder then that the overwhelming emotional tenor of the present is a roiling cycle of rage and apathy, fulminating action or heedless retreat. We should wish to sink into dreamless sleep, but even our attempts at oblivion, the last refuge of the exhausted, are continually interrupted by the glare of streetlights, the noise of traffic, the glow of screens and the ping-ping of push notifications. As Jonathan Crary describes in *24/7: Late Capitalism and the Ends of Sleep*, sleep is the last unexploited and unconstrained domain of human experience, and as such is under relentless attack by systems of governance and commerce. The insomniac, hyperaware and restless in the long hours of the night, is the one who both suffers and subverts this pressure. Insomnia, Crary writes, is "a way of imagining the extreme difficulty of individual responsibility in the face of the catastrophes of our era." (ENDNOTE 1)

Staring out into the darkness, aware of the violence that is being done, and the human suffering it causes, but also helpless in the face of it: this is the weight of insomnia that Liu Xiaodong references in his work. For the artist, insomnia is a product of anxiety, caused by the cares of the world and the feelings of melancholy engendered by rapid development, changing mores, and the incursion of the state apparatus into everyday life. Yet insomnia might also be considered as a reaction against these pressures: an insistence upon other ways of seeing when ceaseless labour or enervated sleep are the only officially sanctioned courses of action. The insomniac endures through the small hours of the night, seeing in the dark and thinking while others thoughtlessly sleep, and it is the liminal, spectral nature of this vigil that gives it its dual quality. (CONTINUES)

〔续〕哲学家伊曼纽尔・列维纳斯（Emmanuel Levinas）曾写道：「失眠是一种醒觉的状态，一种脱离欲望的醒觉。〔注脚2〕我们有必要去思考失眠 — 这个意识中的出口。这个出口其实是另一个世界的入口，一个没有躲避空间的世界。这里没有任何想法、意图或欲望，只有你自己。你只会在失眠的时候才能看见这个世界的入口。〔注脚3〕」刘小东的画就是想表达那种回到盘古初开时的纯粹。他希望能以绘画追求一種客观的看法；即使這客观的看法总爱逃离他。画家的心意能摆平模仿与真实的冲突，令一幅油画与物質世界连系起来。而如果要对抗精神或心意等主观感受，刘小东认为要先将天堂与人间合二为一，我们才有机会享受物件的客观本质。〔注脚4〕

首次发表作品《失眠的重量》的时候，刘小东在展览场刊内写道：「画画源于用物料作出某特定的编排，从而去接触体验物质世界中既有的框架。换句话说，画画是对精神力量的抗衡。」〔注脚5〕然而这个既有的框架是什么？这框架所包含的可以是无尽的。但人类的物料是有限的；人类画的画也是有限的。限于画的大小和画画的时间。画框是画的边缘，里面装着画家耗尽一生的意志与他的独立意识。在这意识之外，物质世界继续自由伸缩，无止境地发出光芒，摇曳于漆黑一片之中。要意会到这种种显现，我们必须领悟到物质内在的庞大框架，及明白何谓建基于一般意识之上的意图。这听起来像是一个没可能的任务，但失眠人却有要解谜的执着。

人类有感被体能及感官感受所限，便想到发明机器，希望令生活变得更好。机器比人类更努力工作、工作时间更长、看得更远，最重要的是它们有跟人类不同的看法 — 即使最普通的闭路电视也能看到人类看不到的红外线及紫外光。闭路电视无间断地看守着每个城市中不同的角落。它们不需要睡觉；它们把所见所闻全都记录下来，把数据库里的硬盘逐一填满。态度严肃却漫无目的；似是洞悉先机却暧昧不明，这些闭路电视其实跟失眠人半睡半醒的状况非常相似。它们是一群没有什么想要的艺术家。

"Insomnia is wakefulness, but a wakefulness without intentionality," (ENDNOTE 2) wrote the philosopher Emmanuel Levinas. "The entire opening of consciousness would already be a turning toward the something over which wakefulness watches. It is necessary, however, to think an opening that is prior to intentionality, a primordial opening that is an impossibility of hiding: one that is an assignation, and impossibility of hiding in oneself; this opening is an insomnia." (ENDNOTE 3) This urge towards a primordial opening, a pure indifference, is present too in Liu Xiaodong's work, when he speaks of the objective view he pursues in his painting, even as it continually escapes him. To intercede between the painting and the world is to assert one's intentionality, one's own passion or spirit as Liu calls it, thus "to defeat the spirit would mean unity between heaven and earth, after which we will be able to enjoy the essence of objects." (ENDNOTE 4)

In his notes to the first iteration of *The Weight of Insomnia* in 2015, Liu writes that "the root of painting was to use material to configure and touch upon the inherent framework of the material world, thus defeating the power of the spirit." (ENDNOTE 5) But what is this inherent framework? It is nothing less than everything, but our materials are limited, and painting by human means is limited too: it is limited in scope and duration, extending to the edge of the canvas, the edge of exhaustion, the edge of the individual's awareness. Beyond this awareness, the material world continues to flex and shimmer; in the dark, in the distance, in its endless change and emergence. To be conscious of this unfolding is to apprehend the vast framework of materials and intention beyond ordinary consciousness, which seems like an impossible task for the individual, and the object of obsession for the insomniac.

In response to the limits of the human body and the human sensorium we have created machines that are capable of working harder, working longer, seeing further, and, crucially, seeing differently. The vision of even the simplest CCTV camera extends into the infrared and the ultraviolet, beyond the range of human sight. It watches incessantly, it does not sleep, it records everything, laying its experiences down in endless realms of memory, which fill up tape reels, hard drives, and datacentres measureless to man. It entertains the same kind of hypnagogic vision as the insomniac, uneasy yet undirected, visionary yet uncomprehending: an artist without intention. (CONTINUES)

〔续〕每一部闭路电视都是一个不眠不休的保安员。刘小东认为它们的专业操守是我们跟机器沟通的第一道桥梁。如一个画家自问没能力达到机器般的劳动水平，他应该将自己跟机器的关系重新定位，因为机器的工作表现比人类更符合今天的生产需求 — 无间断的机械链正在支撑着整个经济效益框架。刘小东写道：「我们必须向机器学习。它们的毅力驱使一种即使没人监视也不会停下来的工作表现。即使这些机器正在取替我们，并改变我们的价值观，我们还是要学会跟它们好好相处。」当大部份人对机器存有消极的想法，刘小东则友好地认为它们只是比较冷静。他将作品中的镜头形容为「一位有智慧的老人，在非常客观和平静地观察这一代人」和「一个拥有无限耐性的沉默老画家，对细节一丝不苟，重复地画着同一个情景。刻苦坚持，绝不让自己停下来，直至它成功将画中所有有形的物件化为抽象。」

但始终机器是机器，每天对着这些没有灵魂的工作伙伴会感到不安、消极是无可避免的。单单是安装在伦敦这一个城市里面的闭路电视已过半百万部，数量仍在不断上升。出乎意料地，市民颇接受这些「客观」的眼睛，而这种客观正正是艺术家希望能仿效的。事实是，现在的闭路电视镜头是有「智能」的，与艺术家作品中的镜头大为不同。这种科技能跟踪拍摄个别人物，还能识别车牌号码及于镜头内发生的所有异常事件。它们看到的不是影像，而是资料。随即它们可以利用这些资料作出进一步的行动，例如发通告、警告及告票等。中国政府最近声称已于境内安装多于二千万部智能监察器，摄录所得的资料已连接到一个人工智能系统，能追踪特定的面孔，及其人物的一举一动，系统能推断他们的性别、年龄及衣物颜色。如于深圳市，系统识别到在红灯时横过马路者的身份后，能自动将他们的姓名跟相片放上公众告示板。就此而言，这部机器的存在是为了巩固政府，协助其对人民的压制，沮丧、忧郁及失眠等情绪问题因此而蔓延。当我们设身处地去考虑机器的存在价值的同时，我们必须小心不能套用其逻辑于自身之上。白天与黑夜；自由与控制；人类与非人类，在这些看似对立的概念之间存在一种共识与体谅吗？这正是机械画家与失眠人必需面对的一大难题。

It's this idea of the camera as sleepless labourer that unites the machine with the human in Liu's vision: if the painter themself cannot fully approach the grinding reality of ceaseless work that is the true framework of the contemporary world, then they must make kin with the machines that are capable of approximating it. "We need to learn from the willpower of the machines, work without pause even if there is no one watching," writes Liu. We need to learn to get along with these machines, even as they are replacing us, setting us aside, and changing our values. In contrast to more dystopian fantasies, Liu generously figures the camera as something kindlier and more dispassionate: "a wise elder, very objectively and very calmly observing the present generation" or "a silent old painter... very thorough about details and with unflagging patience, repeatedly drawing a scene... too diligent to rest, to know when to end, until he transforms this figurative picture into something abstract."

Identifying too closely with the machine is somewhat uncomfortable though; the dystopian aspect cannot be denied. London alone hosts over half a million surveillance cameras in public spaces, a number that is growing rapidly, and whose strange acceptance is predicated on precisely the claim to objectivity which the artist wishes to emulate. Unlike Liu's camera, many of these are 'smart': they can read number plates, track bodies, identify anomalies in their field of view. They do not see images but information about the world, and they act upon it, issuing notices, alerts, and fines. The Chinese government recently claimed to have installed over twenty million smart cameras across the country, connected to an artificial intelligence system which tracks the faces and movements of every individual it sees, estimating their gender, age, and the colour of their clothing. In the city of Shenzhen, the system identifies jaywalkers and automatically posts their name and photo to public billboards. In this way, the machine is inescapably enmeshed with the apparatus of the state itself, with that framework of contemporary society and governance that produces oppression, depression, melancholy, and insomnia. By identifying with the machine, we risk simply reproducing its own logic. This is the conundrum that the machine painter and the insomniac confront: what shared understanding is possible in the fretful space between day and night, freedom and control, human and non-human? (CONTINUES)

Time, 2014, oil on 20 canvases, 60×60cm (23¾×23¾in); overall 240×300cm (94½×118⅛in)

《时间》，2014年，二十幅油画，每小幅：60厘米×60厘米（23¾吋×23¾吋）；总合：240厘米×300厘米（94½吋×118⅛吋）

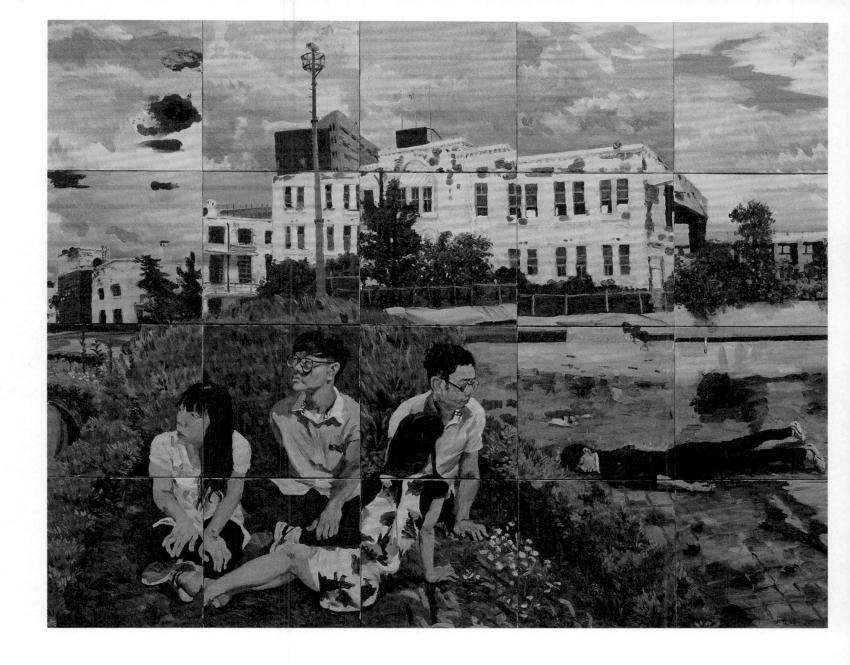

〔续〕机器的运作是以时间为基础的，而人类仅能尽量靠近时间，利用对时间的认知去生活。目前展出于里森畫廊（Lisson Gallery）的画作《时间》（2014年）正是展览中唯一一幅刘小东亲手画的作品。《时间》所描绘的位于是南韩光州的一个场景。画中有一群年轻人，他们的注意力分别集中于躺在地上的一个身躯，和一件没有画进画中的事件。画中背景是发生于1980年的韩国光州大屠杀的场地。当年大概有几百名为支持民主的人被杀。画作由二十个板块组合而成，每一幅都在不同的日子完成 — 这样的构思是为了加强观众对时间流动的感受。画中人物的动作、天空跟所描述的主体感受彷佛都在变。时间好像是一个自我瓦解的过程，好像电影菲林一样，每一格都被之后的一格取替；亦好像拍摄谷歌街景的镜头一样，无休止地记录与更新街道面貌。刘小东用机器画的画中，有很多笔触被重叠地涂改着，制造出一种令人类难以理解的复杂结构。我们也可以把这系列的机器画看成是《时间》的延伸，逐步逐步将艺术欣赏推向一种自动模式，不再以人类观点为出发点。我们姑且暂定这是机器画的画与人类创作的关系与分歧。正在画画的机器好比人失眠时半梦半醒的状态，有一天我们应该能穿过这个失眠的隧道，到达跟机器有内在联系的一个空间。

机器善于以不同的形式捕捉时间。法国艺术家及摄影师路易・达盖尔（Louis Daguerre）于1839年在工作室内把相机对着窗外的街景，拍下一张名为《坦普尔大街街景》（View of the Boulevard du Temple）的照片。这是历史上第一次用机器记录到人类的照片，摄于这条巴黎大街早上最繁忙的时份，理应人头涌涌，但偏偏只能看见两个人影 — 他们分别是一个擦鞋的人与他的客人。受当时的科技所限，要拍一张照片，必须经历十多分钟的曝光过程，所有在这个过程中移动过的物体都会从照片中消失。这位擦鞋人的劳力碰巧将他跟客人深刻地印在这张照片中。就好像机器画的画一样，它会把镜头看到的人类自动删除，因为人类太渺小了，根本不值得放进去这个对世界宏观的诠释上 — 画中描绘的是道路与建筑物等超越个人的公共建设。由此，我们可以看到日常生活的架构与时间的本质。刘小东为作品《失眠的重量》在不同的地点安装镜头，然后电脑将镜头所摄录到的景象变成数据。机器画的不是某一刹那的一个定格，而是幻变的风景。它逐秒逐秒地将景象累积起来，重重复复地画着。这个程式设定为画作带来一种独特的视觉质感。对刘小东来说，这镜头的特性是不可或缺的，他曾解说：「它沉默地观察社会及其变化，无休止地、客观地描画着，直至颜料变得很厚，厚得让这个世界上所有的东西都能被压缩，藏于其内，包括每一分、每一秒。」

The primary dimension in which the machine operates, and which the human is only barely capable of approaching, is time itself—and *Time* (2014) is the only painting by the hand of the artist displayed in the Lisson Gallery's current exhibition. *Time* depicts a scene in Gwangju, South Korea, of a group of young people, their attention split between events out of view and a body collapsed in the background—the site is that of the Gwangju massacre of 1980, an event which occurred before the birth of the generation depicted, but in which possibly hundreds of pro-democracy protesters were killed. Composed of 20 adjacent panels painted on different days, the composition draws attention to time in motion: the movements of the subjects and the sky, shifts in perspective, and the changes in subjectivity that the passage of time makes possible.

Time ruptures itself, like a cinematic reel, or the composite panorama of a Google Street View camera, endlessly recording and updating itself. In the machine paintings, frames are repeatedly superimposed upon one another, producing a composite or palimpsest that grows harder and harder for humans to make sense of as its duration and complexity extends. The machine paintings can thus be seen an as extension of *Time*, pushing further and further into an automated appreciation, further and further away from the human perspective, through the opening of insomnia, until some deeply other yet shared understanding is arrived at.

Machines are good at capturing time—in multiple senses. The first machine image to capture a human form is also an image of erasure: Daguerre's photograph entitled *View of the Boulevard du Temple*, which he shot from his studio window in Paris in 1839. Despite being created at the busiest time of day, during the morning rush hour when the street was crowded with people, only two figures remain: the blurry silhouette of a bootblack and his customer, an act of labour holding them long enough in place that they were inscribed on the minutes-long exposure. So too in the machine paintings: individuals, seen by the camera, are erased in the recording of the scene, too small and helpless to become part of the broader vision. What is depicted is roads and buildings, suprahuman infrastructure, the framework of everyday life—and time itself. The constant superimposition of video frames upon the canvas becomes its texture, an image not of an instant, but of accumulation. For Liu, this is the primary characteristic of his camera, "silently observing society and its changes, continuously and objectively depicting it, until the paint becomes so thick it compresses everything into the painting, every minute and second." (CONTINUES)

〔续〕就画画机器是绝对客观这个论点来说，除了以上述照片为例，摄影机这个器材本身于记录过程中存有的特性和取舍之外，还有第二个令人想不通的疑点，那就是意图的问题。设计师声称机器是客观的。然而在设计过程中，设计师的偏好及个人利益始终会是设计的依归。他们总是有意无意地采用数之不尽的主观看法。以镜头为例，其镜片的曲度、焦距、录影格式、宽频模式、容差、反应时间、缓冲程式及记忆体的大小等，都是某人或某团体的主观决定。其实机器挺会骗人的。当画家谈及画笔的选择时，科研人员则在猜想每一点像素背后隐藏着怎样的演算法。在录影中被聚焦的影像动作又是由怎样的编码决定的呢？究竟是谁的设计？没有自由意志的机器应否是我们用来面对未来世界的伙伴？要思考今天的电子科技如何介入人性，影响我们跟地球的关系，首先，我们要懂得提出以上这些问题。

从前人手运作的系统建基于很多不成文规定之上，大家可以将这些规定翻译为人情味或偏见。相反，电子化系统不容许任何暧昧的信息。它要求我们必须将所有要考虑到的事情编码，清晰无瑕的，这才能运作。这正是现今科技年代一个最大的矛盾。这些潜规则在电子化系统里面无处可逃，商业公司或政府机构标榜的客观完全是个谎言。好比一个画家来来回回地检视着面前的世界与他的画作 — 他追求的是一种对世界客观的描述，每当他尝试，他就发现自己又跌进了一个主观监狱，徒劳无功。主观来自画家的个人喜好与精神力量。机器的运作看似错综复杂，但其实它们的每一个任务都是某人的主意。驱使它们不断工作的是人类的欲望。所谓机器是客观的，说到底不过是虚张声势。事实是，客观与主观根本不能并存，就好比天堂与人间，永远都有个距离。如画家希望将想法、个人喜好和主观视点从画作中除掉，他必须要不断地重新面对作品所描绘的事情，就好像机械画家一样，由一层一层的抽象笔触慢慢形成一个具体的视点。在这追求客观性的过程，我们会发现物件并没有本身。

为了证明创作中存在客观的可能性，画家代入用以监管群众的闭路电视镜头，冷眼旁观地看着机器如何将人化为数据。画家亦尝试过在失眠的过程中，从自己的意识沼泽中挣脱出来，尝试寻找一个能到达客观的出口。结果是画家转了一大圈，回到原地，发现在这个充满无限可能性的世界中，个人意愿原来是最重要的。即使这件工具或这个科技被有权势的人独占，但有一天它可能成为启发创意的新媒体；即使各种限制令我们的视野被收窄，但这并不代表我们看不到新的可能。黑夜中这个画家在帆布上刮着擦着，为的是要看到闭着眼看不到的未来。

A second obfuscation is the multiplicity of intents, biases, and dispositions subsumed into the apparatus of the machine which paints. The machine is deceptive: it makes claims to objectivity, but uncountable decisions, conscious and unconscious, have been embedded into its design and implementation: into the curvature of its lens, its focal depth, its video format, bandwidth, tolerances, response time, buffering and memory. The painter speaks of the choice of brushes but the technologist wonders what the chosen compression algorithm hides behind a pixel, what line of code decides the focus of each movement, and who wrote it? Asking these questions is the first step in reconciling the unknowability of the world with the determinism of the machine.

The paradox of a technological age is that everything once unmentionable, once obscured from public view, every motive unspoken or even unconscious, must be written down explicitly in lines of code in order for it to be enacted. However obscure its rendering, this morass of intent, once appreciated, gives the total lie to any notion of objectivity. Just as the painter looks back and forth between the world and their painting, attempting to objectively depict what they see but falling time and time again into the prison of their own subjectivity, their own passion and spirit, so the machine cannot help but reveal, in its most intricate workings, the endless complexity and variability to which it is subject. The supposed objectivity of the machine is a feint. In this reading, there is no possible unity of heaven and earth, nowhere else to stand, or sleep. To attempt to remove intentionality, passion, subjectivity from the work is to continually recover and re-confront it, just as the layers of abstract marks made on the canvas gradually reveal a concrete viewpoint. The struggle to achieve objectivity reveals that even objects do not possess it.

In the attempt to surrender human concerns to the machinery of surveillance and governance, and in pushing individual sensitivity through the primordial opening of intentionless awareness, the painter comes full circle to assert the primacy of individual agency amid the infinite variety of the world. No tool is too firmly in the grip of power that it might not be prised loose and turned to the service of new forms of expression; no vantage point, even in the depths of darkness, is so sunken that its observations might not entrain new possibilities. The restless insomniac, ever scratching at the canvas of the night, catches sight of futures our light-dimmed eyes might otherwise fail to see.

占士·拜度（James Bridle）是一位艺术家，亦是一位作家，创作媒介跟主题涉猎广博，对科技发展尤其感兴趣。不少画廊及机构曾邀请拜度参与艺术展览及文化活动。另外，他的文章曾刊登于英国《卫报》、《观察家报》、科技杂志《WIRED》、建筑杂志《Domus》、纽约文化艺术季刊《Cabinet》及美国杂志《The Atlantic》等，主题围绕文学、文化及科技网络。2018年，出版社英国及美国出版社Verso为拜度发行了新著《新黑暗时代》。内容检视大众对网络世界的谬误，并探讨科技是否将会为未来带来终结等问题。请浏览拜度的个人网页，查看更多他的作品及个人资讯。jamesbridle.com

〔注脚 1〕　乔纳森·克拉里著，24/7：晚期资本主义与睡眠的终结，Verso出版社，2003年，页18
〔注脚 2〕　伊曼纽尔·列维纳斯著，上帝与哲学 ，在思考里出现的上帝，史丹福大学出版社，1998年，页59
〔注脚 3〕　伊曼纽尔·列维纳斯，歌颂失眠，上帝·死亡和时间，史丹福大学出版社，2000年，页209
〔注脚 4〕　刘小东与本文作者占士·拜度于2019年一个访谈中的对话内容。
〔注脚 5〕　刘小东著，2015年3月8号的日记记录，首次刊登于由张尕编的《术问 — 真实的回归》展览目录，2016年。相同内容也被辑录于这本目录中。

James Bridle is an artist and writer working across technologies and disciplines. His artworks have been commissioned by galleries and institutions and exhibited worldwide and on the internet. His writing on literature, culture and networks has appeared in magazines and newspapers including the *Guardian*, the *Observer*, *Wired*, *Domus*, *Cabinet*, *The Atlantic*, and many others, in print and online. *New Dark Age*, his book about technology, knowledge, and the end of the future, was published by Verso (UK & US) in 2018. His work can be found at jamesbridle.com

(ENDNOTE 1) Jonathan Crary, *24/7: Late Capitalism and the Ends of Sleep*, Verso Books, 2003; p.18

(ENDNOTE 2) Emmanuel Levinas, 'God and Philosophy,' in *Of God who Comes to Mind* Stanford University Press, 1998; p.59

(ENDNOTE 3) Emmanuel Lévinas, 'In Praise of Insomnia' in *God, Death, and Time*, Stanford University Press, 2000; p.209

(ENDNOTE 4) Liu Xiaodong in correspondence with the author, 2019

(ENDNOTE 5) Liu Xiaodong, diary entry 8 March 2015, first published in 'DATUMSORIA' exhibition catalogue, ed. Zhang Ga, 2016. See also this volume.

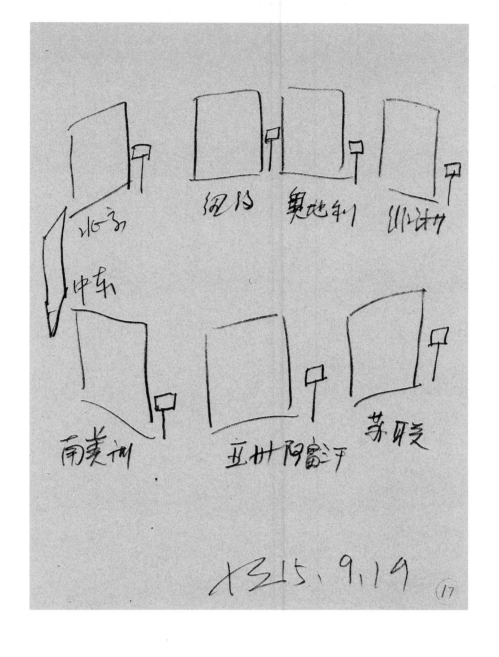

北京 中东 南美洲 纽约 奥地利 非洲 亚洲 阿富汗 苏联

X315.9.19 ⑰

SEPTEMBER 19, 2015: Beijing New York Austria Africa Russia Asia Afghanistan
South America Middle East

2015、10、1

　　中午郭城来工作室、和他沟通了项目进展情况。

　　有两种拍摄办法：

① 象以前一样固定机位，高视点拍摄。

② 额头前戴上特制镜头，目和脑部和手机相连，根据热感应，拍摄。由摄能根据你的注意力的热波拍到你潜意识里感兴趣的人。

我将选择四个地点拍摄，然后定格放映。

机器手能同步喷出色点。

四个地点分别是：

大叙事 { ① 意大利 Lampedusa 岛，这里是难民营。（灰绿色）
　　　　② 巴西奥运会（桔红色点）

小叙事 { ③ 北京东四环秘密看到的拥堵场景（酱紫色点）
　　　　④ 东北金城街道市场（蓝色墨水色点）

NOVEMBER 1, 2015: Guo Cheng came by the studio around midday, we discussed the next steps for the project.

There are two methods of filming:
1. As mentioned previously, affix a camera in a certain location and;
2. Place a special lens in front of the camera body, link it up with the mobile phones and have it shoot only according to heat signals detected. This way it will only shoot according to thermal waves given off towards the person whom you are interested in.

I chose four locations to film, I then need to decide on a way to display.
The robotic hand will spray out paint. The four locations are:

Epic Narrative:
1. Lampedusa, Italy. Refugee Camp (grey/green)
2. Olympic Games in Brazil (orange)

Quotidian Narrative:
3. Beijing East 4th Ring Road from my house, overlooking the traffic (brownish-purple)
4. Street market in Jincheng in the Northeast (blue ink)

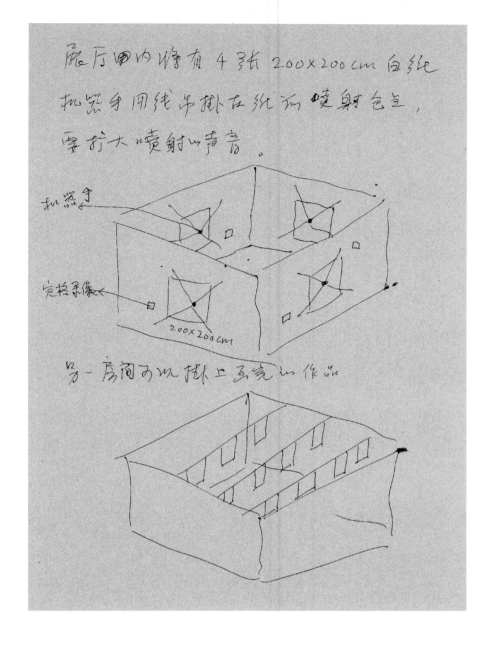

In the exhibition space there will be four 200 × 200cm pieces of white paper. The robotic arm will hang down and spray dots on the paper, the noise from the machine pumping out the colour needs to be loud.

Each finished work will be hung up in a different room.

2016, 5, 7

郭城和 Fito 来到我家，从上东
瞰看四环。拿来口户外监视器，
360°的，对准楼下街道更好，
因为四环太远，影像截取有
困难。

Fito 编程后，便能从视频里
截取汽车、自行车和人的外轮廓廓，
然后输送给绘画机器手，绘制
正在移动的影像。

原计划用机器手正移动的人，
三个小时画一张，画在纸上，用丙稀颜料

MAY 7, 2016: Guo Cheng and Fito came by my house in Upper East Side looking over the 4th Ring Road.
They brought along an outdoor CCTV camera with a 360° view. Looking down the other way to the
nearby road is better as the ring road is too far away and capturing the image is too difficult.

Once Fito programmes it, [the computer] will be able to recognize the outlines of cars, bicycles
and people, afterwards entering this data into the painting machine, from which the robotic hand
can paint down the moving image.

According to the initial plan, the robotic arm will paint people in motion, painting one piece
every three hours on paper using acrylic paint.

昨天我与翁云鹏喝酒时人象吐
聊起此计划，受他启发
决定应该画在画布上，不是三十小时
画一张，而是用展期以三个月画一张，
机器手24小时有不间断描绘城市
移动的人物等色。不间断画在一
张画布上，结果也许就是一张抽象画。
三个月的人物汽车等移动的景色全
都埋藏在不停地描绘中，一层层覆盖
直到三个月结束，作品 结果只有上帝知道
的样子
"忙了半天等于零"，好美的人生。
我也马上通告了翁云，他也觉
得此法更好。

Yesterday I met with Weng Yunpeng and talked about this new plan over drinks. After listening to him I decided that they should be painted on canvas instead of paper, and instead of one painting every three hours, it will be one painting made over the entire three-month duration of the exhibition. The robotic hand will work for 24 hours a day, painting the movements and scenes of the city non-stop. Constantly painting [for such a long time] might perhaps result in an abstract painting, three months of people, cars, etc. moving in the scenery all captured and drawn out by the machine. Layer upon layer until the three months are over, God only knows what the final work will look like. "Being busy the whole day is the same as doing nothing", what a beautiful life.

明天再去李柯工作室，具体落实。

　　也就是说，事到如今，我们
共做三台机器，每台机器各画一张。
三个地点，分别是，北京（我家）
上海（外滩）和东北（我家老家）
三个地点的视频通过网络
远程遥控 直播到上海展厅，三台
机器 在现场同时描绘三个地点.
日夜兼程，不休息 名为《失眠的重量》
　　　　为期三个月

I quickly went and told Zhang Ga, he also feels that it's a better idea than before.
Tomorrow I'll go to Li Ke's studio and let them begin working on it.

So at the moment, we will make three machines, each machine will only paint one canvas.
The three locations will be Beijing (my apartment), Shanghai (the Bund) and the Northeast (my hometown). The recording at each of the three locations will be live-streamed to the Shanghai exhibition space. The three machines will be simultaneously painting on site, painting day and night without rest for three months, the title is *Weight of Insomnia*.

2016. 5. 8

在去李柯工作室之前，网 fito 发现我家的监视装置故障。到我家检查发现网络有问题。

整个楼只有一个网络中心再分配到每户，于是每户的网络容量不足以满足同样的信号。他说他会再想办法解决。

于是我们去顺义李柯工作室。

他们已设计出机器手，是能同时装三只笔的画手，很神奇。

下面是我们的工作计录。

MAY 8, 2016: Before going over to Li Ke's studio, Fito discovered that there was a problem with the surveillance camera installed at my house. When he came over he found out it was a problem with the internet connection.

The entire building has just one central internet connection point which is then distributed to each apartment, so each apartment's internet capacity is not enough for everyone to have the same signal. He said they'll think of some way to solve this problem.

So we went off to Shunyi, to Li Ke's studio. They've already designed the robotic painting hand, it can simultaneously hold three brushes to paint—it's pretty amazing.

MAY 8, 2016: At Li Ke's Studio

Painting brush, use a brush to be constantly painting people, cars, light and other forms. Painting without stop for three months, night and day.

Spray gun no longer to be used.

Weight of Insomnia

The Northeast - Blue
Shanghai - Black
Beijing - Red

访谈 Interview
Liu Xiaodong 刘小东
Karen Archey 卡伦·阿契

刘小东凭着描绘日常生活的油画作品成为一位国际知名的艺术家。他多年来以追求客观为主旨的画作去回应这世界各地历史悠久的写实派，其中包括文艺复兴时期的大师巨匠以致从社会主义延伸出来的写实风格。生于1963年的辽宁省锦州市，刘小东正好见证了中国以至全世界社会过去五十年的急速转变。农业社会被工业化；工业社会被自动化，无数人民于这些经济体系的转化中被直接取代。中国正在经历一轮又一轮的急速发展，刘小东的作品对于日常生活的描绘正好比一面镜子，帮助我们反思这个世代的转变。

他最近的作品系列《失眠的重量》尝试客观地描绘一种悲伤的重量 — 一种不能被描绘的感觉。这跟之前的写实风格截然不同 — 今次作画的不是艺术家的手，而是一只由电脑与相机镜头引导的机械手臂。这个科技装置模模糊糊地描绘由艺术家选择的城市街景，如位于柏林的东西德接合点 — 勃兰登堡门。机械手臂沉默地画着，直至某一个人类把它关掉。最后在几百层的笔触里，画作渐渐远离风景的本质，变为一幅幅重叠着的幻影。

以下是刘小东与美国艺评人及策展人卡伦·阿契（Karen Archey）的访谈，讨论重点为艺术家的创作进化史、其中的创意实践及作品系列《失眠的重量》。

Liu Xiaodong is internationally renowned for his paintings that depict everyday life. Rendered in objective verisimilitude, his work engages realistic painting styles that span various decades and continents—from Renaissance masters to Socialist Realism. Born in 1963 in Jincheng, China, Liu has borne witness to the rapid societal shifts that have characterized both China and the world at large over the last 50 years; as agrarian societies have become industrialized, and industrialized societies have become automated, and countless people have become physically or economically displaced due to these shifts. Liu Xiaodong's work depicts everyday life in China amid these periods of rapid development, functioning as a mirror against which we can ponder the world.

His most recent series, *Weight of Insomnia*, attempts to objectively depict something that is unable to be depicted: the weight of sadness. Departing from realist painting, this series employs a robotic arm guided by a computer and camera lens instead of the artist's hand. This technological set-up muddily depicts urban streetscapes chosen by the artist, such as the East-West meeting point of Berlin's Brandenburg Gate. The final paintings appear as overpainted wraiths, their landscape quality lost beneath the hundreds of layers painted by a robot that paints silently until it is switched off by a human.

In the interview below, Liu Xiaodong discusses his evolution as an artist, his creative practice, and *Weight of Insomnia* with American art critic and curator Karen Archey.

〔卡伦·阿契〕你记得你是什么时候意识到自己是一个艺术家吗?你是什么时候决定要成为一个艺术家的?

〔刘小东〕我十一岁的时候自习绘画，曾参加小学和中学的业余美术组，记得在同学中有竞争意识。直到十七岁考入中央美院附中，才真正意识到要成为艺术家，因为那是中国最专业的美术高中，那里的学生都想成为艺术家。

〔卡伦·阿契〕是什么令你那么小就决定到艺术学院学习？我相信对于从小就开始学习艺术的人来说，艺术最初的吸引来自它提供了一个自由表达的空间，然而很快会发现艺术其实也是一门生意。这么多年来你跟艺术的关系有着什么变化？

〔刘小东〕我决定那么小就从事学习艺术是跟我生存的环境有关。我小时候经历的是六、七十年代的中国 —— 那是一个政治运动频发、非常贫穷的时代。那个时候为了生存，大家都要学一门手艺。其实学艺术是为了生存，等你有了一门生存的手艺以后，你才能够避开所有的政治运动，避开所有的贫穷，混一碗饭吃而已。所以选择学习艺术这条路跟我当时处身的社会环境有直接的关系。 那么，从事了这么多年艺术创作，也就越来越明白艺术和商业是互相掺杂在一块儿的呢。

我认为做一个艺术家，创作时要保持一个坦率的、清澈的心境。至于一件作品中涉及商业的问题，应该由画廊、或者是其他商业性系统去处理吧。那么这样的话呢，艺术和商业的关系才能变得和谐，而不至于互相冲突或者是互相矛盾。

〔卡伦·阿契〕你是如何学会绘画的？你觉得伴随你到今天的哪些艺术教育原则最重要？

〔刘小东〕学画画是从临摹英国古典水彩画开始的，然后才开始学习画静物、风景和人物写生。基本上，我只是直接遵循如意大利、法国及俄罗斯等国家的传统写实油画的训练方式。面对面的直接性绘画一直都是我画画的重要原则。

(KAREN ARCHEY) Do you remember when you realized, or decided you were an artist? How old were you?

(LIU XIAODONG) I taught myself to paint when I was 11, I went to after-hours art groups during primary school and middle school. I remember that there was a sense of competition among us students. Then when I was 17 I was admitted to the high school affiliated to the Central Academy of Fine Arts. That's when I knew I was going to become an artist. It is the most highly regarded artistic high school in the country, and all the students that attend the school want to become artists.

(KAREN ARCHEY) What made you decide to go to art school at such a young age? I think many of us who went into the arts at a young age were attracted to art as an environment of expression, but soon realized that there's a business to it as well. How has your relationship to art changed throughout the years?

(LIU XIAODONG) I decided to go to art school at a young age because of the social situation in my life. The '60s and '70s—when I was growing up—were full of political shifts and social poverty in China. In order to survive at that time, everyone had to learn some kind of craftsmanship skill. To learn art was to survive: only when you own this kind of skill can you avoid all the political movements and step out of poverty—you can survive. So it's strictly related to the social environment I was living in. Then, after so many years of practicing art, I began to realize that art and business are interconnected more and more.

I think an artist should keep a simple and pure mind to the artistic creation, the business part should be handled by galleries and other commercial systems. In this way, the art and the business can be harmonious without getting into conflicts or causing contradiction.

(KAREN ARCHEY) How did you learn how to paint? What were the most important principles of your artistic education that have stayed with you to this day?

(LIU XIAODONG) I started by copying British classical watercolour paintings, then still life, landscapes, people painted from life. I basically followed the traditional training methods of realistic oil painting of countries such as Italy, France, and Russia. Face-to-face direct painting has always been an important principle of my painting. (CONTINUES)

〔续〕〔卡伦·阿契〕写实风格的油画是由很多，甚至是相反的意识形态流传下来的遗产。在西方，写实风格是从如文艺复兴及黄金年代这些近代历史演化衍生出来的。而在中国，写实风格的作品则与社会主义思想密不可分。于创作时，你会选择去应付这些遗产意识，还是会尽量避开这些沉重的历史意义？

〔刘小东〕我认为写实的油画的确是从文艺复兴一直到现在，而中国的社会主义现实主义对我产生过很深的影响。就这种影响方面来说，我认为我在学习阶段时吸收到的是来自中国传统文化的一种训练方式。我并没有对这种文化遗产避而远之；反之，我保持着与这种文化正面交锋之态。学习绘画，要先向前人学习，这是在中国一贯的传统。慢慢地积累经验，你就会开始懂得怎样形成你个人的特征和风格。这种传统我觉得是有道理的，我也是按这个传统进行了自己的艺术实践。我希望自己能在前人建立的基础上有所贡献。对我来说，能创作出属于自己的艺术面貌是非常重要的。

〔卡伦·阿契〕在一个與白兔畫廊的访谈中，你提到美院毕业最难忘的记忆是从集体工作改成个人工作。你当时是否有失落的感觉？在你的作品中你是否喜欢以集体的形式工作？

〔刘小东〕一方面有些孤单的失落感，另一方面远离身边人的竞争，从而更清晰地面对自己。喜欢集体活动是防止过于沉溺于自己，防止心理有病。

〔卡伦·阿契〕在那次访谈中，你提到了你老家有个造纸厂。在另一次访谈你还提到：「对于我来讲，失眠不仅仅属于人类。我还记得我小时候看到的机器都在遵循着人类的需求和命令，从来不会停下来的。我们想象机器能够不停的工作。我的想法是把机器当成画家，让它逐帧地画所看到的，这个比画家用眼睛去看要客观多了。」这是你提到的造纸厂吗？这家造纸厂或其他工厂对你的作品有影响吗？

〔刘小东〕是这样的。造纸厂是儿时记忆最深刻的。因为我的家乡就是围绕着这个造纸厂的小镇，机器的轰鸣和人的生老病死都在这里发生。

(KAREN ARCHEY) The legacy of realist painting is one that is heavy with many, sometimes opposing ideologies. In the West realism is associated with pre-modern periods such as the Renaissance and Golden Age, while in China realism is associated with Socialist Realism. Do you engage these legacies or prefer to stay clear of this weighty history?

(LIU XIAODONG) I think realist painting is indeed linked to the Renaissance, right through to the present. In China, Socialist Realism had a huge impact on me. And in terms of this kind of influence, I think that I absorbed a kind of practice of traditional Chinese culture. I did not avoid this heritage, but instead I maintained a confrontation with the culture. In Chinese culture, it is customary to learn painting from our predecessors. This slowly accumulates and you form your own set of characteristics. I believe in this kind of tradition, and I have been carrying out my artistic practice this way. I personally hope to be able to make my own contribution upon the foundation from the predecessors. It is very important to me to create my own artistic features.

(KAREN ARCHEY) In an interview with the White Rabbit Art Gallery you stated that one of your most stark memories on graduating from art school was transforming from the collective or communal to an individual form of working. Was there a sense of loss associated with that? Do you currently enjoy working communally within the production of your work?

(LIU XIAODONG) On one hand there was this sense of loss that came from being alone, on the other hand, putting distance between myself and the competition of the people around me allowed me to look at myself more clearly. Working communally keeps me from overindulging myself, it prevents me from developing anxieties.

(KAREN ARCHEY) In the same interview it was mentioned that there was a paper mill in your hometown. In another interview you stated, "So for me, insomnia doesn't merely belong to mankind. I can recall from my childhood memories where machines never stopped, following human's wishes and orders. We imagine that the machine could keep working without a break. The idea is to make the machine as a painter, to paint what it sees, frame by frame... it's more objective that what is captured through a painter's eyes." Was this the paper mill that you were referencing? Did this paper mill or other industrial factories have influence upon your artwork?

(LIU XIAODONG) Correct. The paper mill is the most vivid memory from my childhood. My hometown revolved around the paper mill—the roar of the machines. The entire cycle of life and death happened here. (CONTINUES)

〔续〕〔卡伦·阿契〕小时候在老家被造纸厂包围的生活是你创作时经常会出现的主题吗？

〔刘小东〕在我童年回忆里面存在的造纸厂是我认识这个世界的基础。那么这个基础会经常出现在我的回忆里，也会影响我对其他地方的描绘。譬如说，我到了一个完全陌生的环境，我感到很迷茫，我不知道该怎么下笔的时候，我就会根据我的童年回忆去决定如何处理当下眼前的事物。因为其实我们有很多共性。有时候我们的长相有一点儿像；有时候我们的街道有一点儿像。人和人的关系也有很多相似的地方。由此，我能进入他们的生活；了解他们；描绘他们，这是我儿时那家造纸厂对我的影响。这种基础对我来说是很重要的。

〔卡伦·阿契〕除了绘画，你也会通过如电影及摄影等媒介去创作，亦会将自己的想法一一写进日记里。这些其他的媒介有辅助你绘画的作用吗？你认为绘画是你的首要创作实践吗？

〔刘小东〕绘画是我的主要业务。电影、纪录片及日记等等是对绘画的补充。这种补充使观众更能了解我的思维和我的思想过程，以及我对世界的看法。

对于我自己来讲，做电影跟写日记等等的一系列活动，也是使我变得开放的过程，我认为一个画家，没有一个开放的思想，就会走向僵化，走向一个死胡同。所以开放的思维对于一个画家来说非常的重要。

〔卡伦·阿契〕是什么灵感启发你去创作《失眠的重量》？ 我曾在你的日记和访谈中看到，最开始是想要衡量悲伤的重量。

〔刘小东〕当人悲伤时经常会感到无力，有时候甚至想要躺下来。我最初就想测量这股强大的精神重量，但这等于测量灵魂的重量，根本无法量化。于是慢慢推演出《失眠的重量》。机器不停地描绘镜头里的景物，层层叠叠，形成视觉与心理上的重量。

〔卡伦·阿契〕这幅过分琐碎、层层叠叠地被画着的风景画表达了一种要去形容现实的重量。这种重量与悲伤的重量可以相提并论吗？抑郁的人会沉重地看很多事情，很难客观地检视所谓现实为何物，生活上简单的工作也变得难堪。你的作品尝试去捕捉的悲伤感觉是大部份人想尽办法去逃避的。我认为你这样的做法很勇敢。

〔刘小东〕我认为悲伤的来源有很多种，而且每个人都不一样。然而层层叠叠的风景也许能够表达一种悲伤的感受；这种悲伤可能來自我们于事业上、感情关系上、家庭上、人际关系上及思考自由时的烦恼。好比这幅层层叠叠的风景画，我们这些烦恼也在每天层层叠叠地重复着。这些烦恼也许会带给我们很悲伤的情绪，因为我们不知道该怎么解决。那么面对麻烦，或者面对悲伤的时候我认为最好的解决办法就是直面它们。一点一点地面对它们，解决它们，从而使我们心中的悲伤，获得一种释怀或者一种解放。我们是无法逃避悲伤的。

(KAREN ARCHEY) Does the papermill, or the memories of life being surrounded by a factory, frequently come up in your artwork?

(LIU XIAODONG) The memories of the papermill from my childhood form the basis of my understanding of the world. This image often appears in my memory and it affects me when I paint other places. For example, when I'm in a completely strange environment, when I'm confused and not sure how to paint, I recall the memories from my childhood to decide how to deal with the things in front of my eyes. People have a lot in common with each other, some have similar appearances, or some streets are very much alike. The relationships among people have lots of similarities with each other. Through this resemblance, I am able to enter their lives, to know them, to paint them. This is how the papermill of my childhood has influenced me. For me this kind of basis is very important.

(KAREN ARCHEY) In addition to painting, you work with media such as film and photography, and keep detailed notebooks of your thoughts. Are these media supplemental to your practice? Do you consider painting to be your primary practice?

(LIU XIAODONG) I mainly work with painting, other elements like film, photography, or notebooks support the painting. This enables people to know more about my thoughts and ways of thinking, as well as my point of view onto the world.

Through activities like filmmaking and diary writing, I become more open. An artist can become paralyzed without an open mind and thinking, and this will lead to an impasse. Therefore, a more open approach of thinking is very important for a painter.

(KAREN ARCHEY) What was your inspiration for creating *Weight of Insomnia*? In your diaries and interviews I have read that you initially wanted to gauge the weight of sadness.

(LIU XIAODONG) When people are sad, they often feel powerless and sometimes even feel the physical need to lie down. At first I wanted to measure this powerful spiritual weight, but it was like measuring the weight of the soul, which could not be quantified. *Weight of Insomnia* has gradually derived from this. By constantly depicting the scenery captured by the camera, layer upon layer, the machine forms a visual and psychological weight.

(KAREN ARCHEY) Thus it is the weight of the depiction of reality—literally the overwrought, overpainted landscape—that represents the weight of sadness? When someone is depressed they have a difficult seeing reality for what it is, and there is a weight to everything, even the simplest of tasks, that seems unbearable. I find that quite brave, that you want to give shape to this feeling of sadness that most people want to avoid as much as possible.

(LIU XIAODONG) I think there are many kinds of sources for sorrow, it is different for every person. Landscape with layers upon layers might be able to express a sense of grief, or issues surrounding our careers, relationships, affections, family and acquaintances as well as freedom and so on. Like the layers of the landscape, we face a lot of troubles. These troubles could perhaps bring us sorrowful feelings, because we do not know how to deal with them. So when facing sadness, I think the best solution is to confront these feelings. Confronting them bit by bit, and solving them so the sadness in our hearts will receive a kind of relief or liberation. We cannot escape sadness. (CONTINUES)

〔续〕〔卡伦·阿契〕你能描述一下《失眠的重量》的创作过程吗？你如何选择这些作品中所描绘的街景？

〔刘小东〕说来话长。机械工程师、电脑程式设计师和我一同用了长达一年半的时间慢慢使《悲伤的重量》实现成可视化的《失眠的重量》。至于街景方面，我通常会选择有某种象征性的地点。比如北京是在政治和交通方面都有强大压力的城市，我就选择了一个拥堵的十字路口；柏林是东西德统一的城市，我就选择了勃兰登堡门。

〔卡伦·阿契〕你在与白兔画廊的访谈中这样说 ：「我的习惯是先看要画的人或物才下笔的，边看边画的一个过程。我尽量使用一个客观的方式而不是主观的方法，一种非常客观的态度，每一个笔触之后都带着客观的眼光。所以说这个机器比我更客观。它用同样的方式，通过镜头看街景，然后看一眼画一笔，所以它有比我更客观的态度。」在这个访谈中，你说你对与机器打交道感兴趣，因为机器比画家的眼睛更加客观。为什么客观性那么重要？在我看来（至少在西方），绘画是与主观和感情相联系，而不是理性。你是想通过科技工具来计算不可计算的（比如情绪）吗？

〔刘小东〕是的，我就是天真地想用科技工具计算不可计算的东西，比如说悲伤和快乐等这些感受。另一方面我也讨厌艺术家过于自以为是、装模作样。

〔卡伦·阿契〕你会界定什么行为是自以为是或者是装模作样呢？艺术家需要长时间面对自己的想法，才能知道怎样对世界表达。这个过程需要很大的自信。因此，我认为大部份艺术家创作的时候都要带点适当程度的自以为是。

〔刘小东〕自以为是或者是装模作样都跟我的生存状况有关。其实在中国，我的生活环境，是经历过文化大革命啊，很多种政治运动的一个环境，那么在那各种状态下，人都为了政治，为了生存，为了等等等等，都会变得装模作样的，而缺少一种客观的判断。所以呢，客观性对于中国人来讲是非常非常重要的。这跟其他的社会结构不太一样，我们太缺少客观性的一种社会环境。

(KAREN ARCHEY) Could you describe your process for making the works in *Weight of Insomnia*? How do you choose the street landscapes that are depicted in these works?

(LIU XIAODONG) It's quite a long story to tell. The mechanical engineer, the programmer and I worked for a year and a half to slowly implement *Weight of Sadness* into the visible *Weight of Insomnia*. As for the landscapes, I usually pick iconic locations, for instance in the Beijing painting I chose a busy crossroad as a symbol of the pressure that comes from both politics and traffic. For Berlin, the city of the unity between the East and the West, I chose the Brandenburg Gate.

(KAREN ARCHEY) From the White Rabbit interview: "In my painting practice I believe in looking at the subject and then painting; a process of one look and one brushstroke. I'm trying my best to pursue an objective rather than a passionate approach, a very objective attitude—every brushstroke followed by an objective look. So this machine is more objective than me. It takes the same approach, it looks at the street scene through its lens, then draws one look and then one brushstroke, so it has a more objective attitude than me." In this interview you state that you were interested in working with machines because they are more objective than the painter's eyes. What drew you to privileging objectivity? In my mind (at least in the West), painting can be associated with privileging passion and subjectivity over rationality. Are you attempting to calculate the incalculable (such as emotions) through these technological instruments in your work?

(LIU XIAODONG) Exactly, I'm naively using technology to calculate the incalculable, such as sadness, happiness and so on. I can't stand artists who are overly self-righteous and pretentious.

(KAREN ARCHEY) I wonder what behaviour you would qualify as being self-righteous or pretentious, because I personally think that most artists have to be a bit self-righteous (in a good way) in order to make their work. It takes a lot of confidence to be able to spend so much time with your own ideas and to communicate these to the world.

(LIU XIAODONG) Self-righteousness or pretentiousness are aspects that relate to my living circumstances. The Cultural Revolution was a time full of political change. Under that situation, whether it was for political reasons or just for survival, people were all pretentious and lacked of an objective viewpoint.

Objectivity is very important for the people of China. It is different from other social structures—here we lack an environment that has objectivity. (CONTINUES)

〔续〕〔卡伦·阿契〕但是，据我所知，你过去的绘画创作都在客观地描绘一群平凡的老百姓。艺评人卢迎华曾于斐列兹艺术杂志这样形容你的作品：「一种对客观性的追求。即使有时画作中有某一人物较为突出，但仍无阻大部份中国人感同身受，因其表达方式充满活力和感染力。」如是说，卢迎华的意思是你会以一种客观的手法去表达情感，在很个人的层面上感动到每一个中国人。你认为你创作中对老百姓日常生活的描绘是超越评论层面的、对中国或以外地方的一种反映吗？你认为当艺术家以这样的角色于社会存在，是自以为是的吗？

〔刘小东〕当然这个也是跟我刚才说过的生存环境有关。我觉得体验或者描绘人的日常生活，对于我来讲非常重要，他的重要性就在于日常生活中我们能够得到一种客观的观看，能够体验到社会的变化，对每个人的生活带来的影响和变化。我们也试图在日常的生活中获得一种相对自由的状态。毕竟我们都面临着巨大的社会变迁带来的压力，以及政治环境对个人自由的压力，所以日常生活的自在性变得非常非常的重要。

中国几千年来的生活都是有上层帝王权势生活和下层老百姓的日常生活相对应的一种状态。这种老百姓的世俗生活非常非常重要，维系着社会的基本稳定，描绘他们是非常重要的一件事情。

〔卡伦·阿契〕《失眠的重量》是属于什么艺术类型？绘画、有时间性的媒体、两者都是还是其他类型呢？

〔刘小东〕我称之为「绘画永动机」。就是基于时间的绘画痕迹，算是一种新媒体艺术吧。

〔卡伦·阿契〕完成这个系列的一张画需要多久？跟你的手绘作品所用的时间很不一样吗？

〔刘小东〕制作所需的时间会受展期的长短影响，通常五个星期到三个月之间。我的手绘作品需时要短一点，同样的尺寸会比它快一到两个星期。

(KAREN ARCHEY) However, I know that your painting work in the past was concerned with depicting groups of everyday people. As Carol Yinghua Lu wrote in *frieze*, your work, "Sought objectivity; their depictions were lively and contagious, sometimes focusing on the individual but often in a way that was relevant to the lives of most Chinese people." Thus Yinghua Lu is saying that your work takes an objective approach to depict sentiments that would touch each Chinese person on an individual level. Do you see your practice as a meta-commentary on the daily lived experience of people, in China and beyond? Do you think there is a self-righteousness associated with this role of the artist?

(LIU XIAODONG) This comes back to the circumstances I mentioned before. I feel that it is very important for me to experience and depict everyday people, the importance of it lies in the fact that we can get an objective view of the everyday life and can experience the changes in society—the influences and changes that occur in everyone's life. We also try to achieve a state of comparative liberation. After all, we all face the same pressures under the social transition, and the stress from political environments on individual freedom, so the autonomy of every life becomes really important.

For thousands of years, life in China had been a balance between the life of the upper Imperial power and the everyday life of the lower class. This secular life of the common people is of great importance—they maintained the basic stability of the society, it is important to depict them.

(KAREN ARCHEY) What genre do you consider the *Weight of Insomnia* work to be in? Painting, time-based media, both, or another genre?

(LIU XIAODONG) I call it "perpetual-motion machine painting." It's time-based painting marks, I guess it counts as new media art.

(KAREN ARCHEY) How long does it take to finish a painting in this series? Is this quite a different period of time that it takes for your hand-painted works?

(LIU XIAODONG) It changes according to the duration of the exhibition, usually between five weeks and three months.

My hand-painted works usually take a shorter time, it would probably take me one or two weeks less to hand-paint a canvas of the same size. (CONTINUES)

〔续〕〔卡伦·阿契〕因为《失眠的重量》不是手绘的原因，这个系列跟你之前的的画作看起来非常不一样。虽然新旧作品都是风景画，但这个系列比之前抽象多了，接近看不出来画的是什么。你曾提及自己在写实风格绘画训练中的经历，请问你可否形容一下你如何决定以抽象化的方式表达《失眠的重量》？你是如何控制（或不控制）画作的美学？

〔刘小东〕就这个项目来说，我们设置好了程序以后，我就不控制它了，完全由机器自己去描绘镜头前的景象。那么这种不控制的结果就会带来这样的状态，就是说，描绘的时间短，大家就看着是一个具象的绘画，如果反复的描绘时间长，眼前的街景就会变成抽象的。

这个对于我来讲是一个很有趣的现象，也许这个现象能令我们更了解这个世界。我们常常觉得只有一个世界存在；其实可能还有另外一些跟我们认为「真实」的这个世界很不一样的世界存在啊。那么这个命题是很有趣的，在这个命题面前，我甚至忘记了审美，忘记了写实和抽象的区别，我觉得这些都不重要。重要的是，我们看到的世界和世界本来的样子是一样的吗？我们看到的世界是真实的世界吗？那么这种客观性的存在，是不是真正的存在？等等等等我也想不清楚的问题，但是这些恰恰也都是很有趣的问题。所以我不愿意控制这张绘画的结果，让它自己形成自己的结果。同时也给我惊喜。

〔卡伦·阿契〕所以這個過程中是否有某種偶然性？ 结果总是令你满意还是有时候你会丢弃一些画？

〔刘小东〕当然有偶然性。我最满意的绘画往往是我几乎放弃，又通过努力挽救回来的。这个过程是很煎熬的，有时实在无力挽回就放弃了。

〔卡伦·阿契〕就你过去的创作而言，你的作品有时颇有政治意味，如画作《时间》（2014年）。这是一幅由不同板块组合而成的画作，其中描绘的是发生于1980年韩国光州的学生运动，人物是当年抗议者的儿女，这批抗议者一部份更在大屠杀中被杀害了。除机械手臂之外，作品系列《失眠的重量》还应用到闭路电视这个科技。这些闭路电视的位置都是极为繁忙的公众地区，如英国伦敦的特拉法加广场。你选择的公共广场其实是一种奇怪的地方。虽然人多挤迫，但人们普遍在这种广场里有一种匿名的安全感，而今天的监控科技有效地夺取了这种匿名的自由。《失眠的重量》算是你对现在监控科技无处不在的一个评论吗？

〔刘小东〕我认为政治无处不在。我觉得无论在任何一个国家，政治在每个人的生活中都产生了重大的影响。然而这些透过镜头画的画是对科技发展的一种质疑。也就是说，在科技和现代化的进程中，我们人类的原始的快乐和自由受到了很多的束缚，这一点是我在生活中体会到的。也就是说，我们的快乐越来越受政治影响和科技发展影响。

(KAREN ARCHEY) Because they are not hand-painted like the rest of your works, the paintings in *Weight of Insomnia* appear aesthetically very different from the rest of your works. Despite depicting a landscape, they are more abstract, sometimes to the point of not being recognizable. You have mentioned your training and background in realist painting—could you describe how you used abstraction and how you control (or don't control) the aesthetic of the works in *Weight of Insomnia*?

> (LIU XIAODONG) Once we set up the program for this project, I have no control over it—the machine will draw the scene in front of the camera. This uncontrolled method will dictate the result. That is to say, if the depiction time is short, people see it like a figurative painting, if repeated for a long time then the street scene will become more and more abstract.
>
> To me this is a very interesting phenomenon, and can be related to us getting to know the world. We think to ourselves that there is only one world, but perhaps it is different to the real world. This thought is very interesting to me and I begin to forget aesthetics, and the difference between realism and abstract. I felt like none of this matters anymore. What is important is to question if the world we see through our eyes is the same world as itself? Is the world we see the real world? Is this objectivity really there? Questions like this continue, I do not know the answers—they are all fascinating. Therefore, I do not wish to control the result of these paintings, rather let them form their own consequences. This continues to surprise me.

(KAREN ARCHEY) Thus, there is an element of chance involved with this process? Are you always happy with the result, or do you discard some paintings?

> (LIU XIAODONG) There's definitely an element of chance involved in the process. The paintings I am more satisfied with are often the ones I was almost about to give up on, but then I worked hard to save them. Sometimes though I really have no way to redeem a painting and I just give up.

(KAREN ARCHEY) Along with robotic arms, the technology used within *Weight of Insomnia* includes surveillance cameras. These are pointed at high-traffic public areas, such as Trafalgar Square in London. Given that some of your other work has been quite political in nature (such as the multi-panel work *Time* [2014], which depicts the 1980 South Korean student uprising via portraits of the children of protestors, some of whom were killed during this massacre), are you also making a commentary on the omnipresent state of surveillance technology? The public square is a strange place in which many people feel quite safe and alone in their anonymity while in the proximity of many people—surveillance technology effectively eliminates that anonymity.

> (LIU XIAODONG) I think politics can be found everywhere. In any country, politics make a huge impact in all our lives. However, the camera-painting in my works questions the development of science and technology, that is, the progress of science and technology as well as modernization. In fact our primordial joy and freedom as human beings is constrained; this is what I experienced in life. That is to say, our happiness is increasingly influenced by politics and technology.

其实在没有看见李珂（工作室）设计出来的
机器手的时候，我一直喜欢用喷枪的
方式，也就是把人和车都变成点。用
喷枪喷在画布上，喷枪发出类似
无声手枪或心脏跳动的闷声，射在
画布上，当看到机器手上能装三只笔（失眠时）
的装置很的好喜欢，于是就决定
让机器一点儿声音都没有，默默地
一笔一划地画上三个月。郭城也赞同的改变

我想到了淡勃，他正在研制中国古代
毛笔。他帮我们能注入丙烯颜料
的毛笔。机器手接着他默默工作也
是好动人的过程。

Before I had seen the design plans for the machine put forward by Li Ke's studio, I had already thought that I'd like to use a spray gun and turn cars and humans into dots—use the spray gun to spray dots on the canvas. The spray gun will emit a sound like a gun, like a heart skipping a beat in the midst of sleeplessness, shooting onto the canvas. When I saw that three brushes could be affixed to the robotic hand, I really liked the result so, it was decided to use the robotic hand which would emit no sound at all instead, silently painting one brushstroke at a time for three months. Guo Cheng also agrees and liked this changes.

I thought about Dan Bo, he is in the middle of researching into ancient Chinese brushes. He'll help us find the kind of brush best suited to acrylics. Seeing the machine silently working away is pretty fascinating.

2016.6.18

郭城和Fito 下午在上东城寓
所安好监视器。在任何有网络
的地方打开手机都能看到镜头里
的绘景。一切正常。4点多钟轩到
李珂工作室，他们基本做好了框架
和移动机罗械装置。我现场
用即嗽助的颜料抹成几块颜料。
韩国的艳紫红、人工娇绿都对口味。
德国的爆灯黑、深墨绿和铁锈擦色
也对味儿。中国的亮红、牙黑和
青～～兰色自搭配一起不太准确，
越了解诚深入呆长的地方绘之
拿不准色彩。明天再试之黄色、灰色和红色。

JUNE 18, 2016: Guo Cheng and Fito came by my house at Upper East Side this afternoon to install the surveillance camera on the terrace. You can see whatever the camera sees through a website on your phone. Everything is going according to plan. A little after 4pm we went to Li Ke's studio, they are more or less completely done making the machine's framework and moving components. While I was there I used the paints donated through the support of a Japanese company to paint down a few samples. For Korea, a gaudy reddish purple and a bright synthetic green will work well; for Germany, lamp black, deep pine green and a rusty brown also work quite well. For China the bright red, ivory black and bright blue [I chose] when put together don't seem all that apt. The more you know a place and the longer you've spent there, the more difficult it is to grasp the appropriate colour. Tomorrow I'll try yellow, grey and red.

晚上请团队吃饭 我强调
要保证机械 ~~□□~~ 一直运转很重要，
只要不停电，就要运转。如果网络有卡，
就让让机械手重画画缺失的，就是
不顺停下来，更不能无故停机。
　因为我们看过太多中国式的影像
互动展，往往为了省电省事儿就
停止运转，好像只为开幕一天服务。
　我们要向机器的任性学习，不停地
工作，哪怕没人观看，哪怕追不上
街景人流车流的变幻化。机械一直
要傻傻工作。这是信用，~~中国人~~ ~~最缺失~~
的品德。　　　~~最重要~~

In the evening I invited the entire group out for dinner, I underlined again that we need to ensure that the machine is always working. Unless there is a power cut, it has to be moving. If there is a break in the internet connection, maybe the machine can go back and repaint the forms it missed—what is important is that it doesn't stop, there should be no reason to turn off the machine.

It's because we've all seen too many Chinese-style interactive video exhibitions, where to save electricity and save hassle they turn off the machines and usually only have them on as a service during the opening. We need to learn from the willpower of machines, work without pause even if there is no one watching, even if it can't catch the shifts in the movements of the flows of people and cars, the machine has to keep on stupidly working. This is what trust is—the most important of all virtues.

2016,6,20

昨天画了一天色块，主要是
红、黄、灰。想用红代表北京，
黄是上海，灰是东北老家。
觉得这样更象中国地区的色彩。
　　沉淀一天，今天再看，还是

● 18号最早的红、黑、兰好。
红是北京，黑是上海、兰是老家。
那红、那黑、那兰也正贴近
失眠时心里及眼前的状态。
色彩远不散的~~失眠~~失眠压力此
接近
接近要稳一个地区的本貌色更重要。

JUNE 20, 2016: Yesterday I spent the day painting colour samples, specifically reds, yellows and greys. I want to use red for Beijing, yellow for Shanghai, and the grey will be my hometown in the Northeast. I think these colours are more Chinese.

I let it settle in for a day and looked again today, and went back to the initial red, black, and blue I decided upon the 18th: red is Beijing, black Shanghai and blue for my hometown. That red, black, and blue press closest to the state of the soul and the world before your eyes in sleeplessness.

That the colours should be closer to the feeling of the pressure of insomnia—which cannot be dispelled—is more important than the delusion of being able to find colours which express the nature of a place.

事情往往是這样，越逼近
想法越多，越多就越难以选择，
而且往々愈远离初衷。

回到原初，最早的想法是忧伤
的重量，那么色彩的选择就在回到
这个原点。

红、黑、和兰，有忧伤、失眠的
痛感。仅只如此。

This is as far as everything has gotten until now, the closer I get to the actual exhibition date, the more ideas I have. The more ideas I have, the more difficult it becomes to make a decision, and the further away I get from my original intentions.

Go back to the beginning—my earliest thought was on the weight of sadness, so in choosing the colours I should go back to that starting point. Red, black and blue all have the keen feeling of sadness, of sleeplessness.

So it goes.

2016、7、16

回想来孟加拉的前几天也真是
无缝对接的日子。

9号在到上海参加 CAC 开幕式。
10号在去无锡参加宋迎春五郎
　　的开幕展。
11号赶回上海在外滩三号组装
摄像头。
12号前往东北老家哥々的小舅子
家组装摄像头。

13号在
　　装完摄像头，给父亲叩头上坟
14号飞赶回北京，直接去李明
　　的城市宾馆探讨摄像头的地点
　　　　已是下午2点

JULY 16, 2016: Looking back, these past few days before coming to Bangladesh really went by seamlessly.

9th: Went to Shanghai for a CAC opening.
10th: Went to Wuxi to attend the opening exhibition of Song Yingchun's gallery.
11th: Back to Shanghai to install the camera device at No. 3 on the Bund.
12th: Off to my hometown in the Northeast.
13th: Install a camera at the home of my brother's brother-in-law's house. After the install went to pay my respects at my father's grave.
14th: Back to Beijing. It was already 2pm and went directly to Li Ming's Chengshi Binguan to try to find a good location for shooting.

最后决定把在上东敝家里架好的摄
像头转移至城市实践。这边的19楼
窗口正对三里屯北街十字路口。如果
不出意外，北京的这张画将呈
红色的大叉子。

　4点田又开车奔向顺义李珂的作室，
查看机械画笔的进展。机械画笔
在画布上的慢慢移动，画出蓝色的
笔痕，初见模样。

　回到家已是晚8点。饿瘪了。
吃完剩饭收拾行囊已近半夜。
第二天一早4点起就床，5:20飞往
孟加拉，进行下一个项目的探点儿。

We decided to move the camera installed at my home at Upper East Side to here. The window on the 19th floor looks directly down on the intersection on Sanlitun North St. If there aren't any problems, the Beijing painting should just be one big red cross.
4pm drove again up to Shunyi to Li Ke's studio to see the developments made on the painting brush mechanism. The mechanical brush moves very slowly over the surface of the canvas, it paints down faint traces of blue which are beginning to take shape.

By the time I got back home it was 8pm. I was starving. I ate the leftover food and by the time I packed my suitcase it was already midnight. I have to get up tomorrow at 4am and leave for Bangladesh at 5:20am to start research on the next project. I was in Bangladesh looking at the locations while also worrying about the problem of my lost baggage. Now after midnight I finally have time to look at my phone and check out the feed from the cameras.

在孟加拉省生儿的同时也着急
去行李的问题。现在已近
半夜才方空务之手机里几分摄像之
此情况。

上海外滩半夜灯火通明，清晨无人
北京上东半夜灯火不大通明，清晨
无人。
东北老家半夜漆黑，没有半点灯光，
清晨因人满为患。

大城市睡懒觉，小城镇早起床。
无底的漆
看到家乡的漆黑我难过，那是一个黑窟窿。
看到家乡人早起的正能量，我又
自责自己半额的后半生。

The Shanghai Bund at midnight is still as bright as day, it is just before dawn and no one is about.

Beijing Upper East Side the lights are not too bright, it is before dawn and no one is about.

My hometown in the Northeast is pitch black, there is barely any light at all. It is before dawn and it is full of people walking about. People in the cities sleep in, in the small towns everyone is up early. Watching the darkness of my hometown makes me a bit sad, it is a bottomless black hole. Watching the people of my hometown waking up early with such positive energy, I can only blame myself for my semi-declining second half of life.

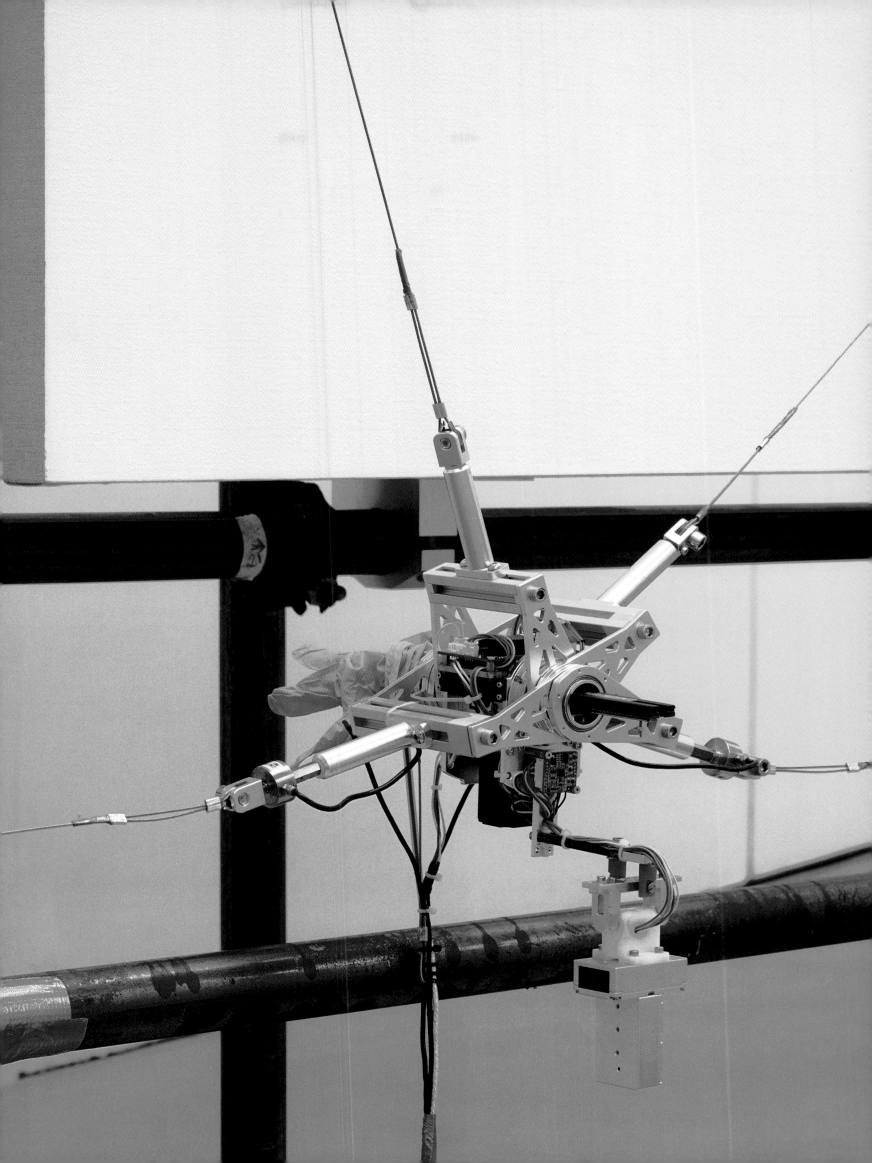

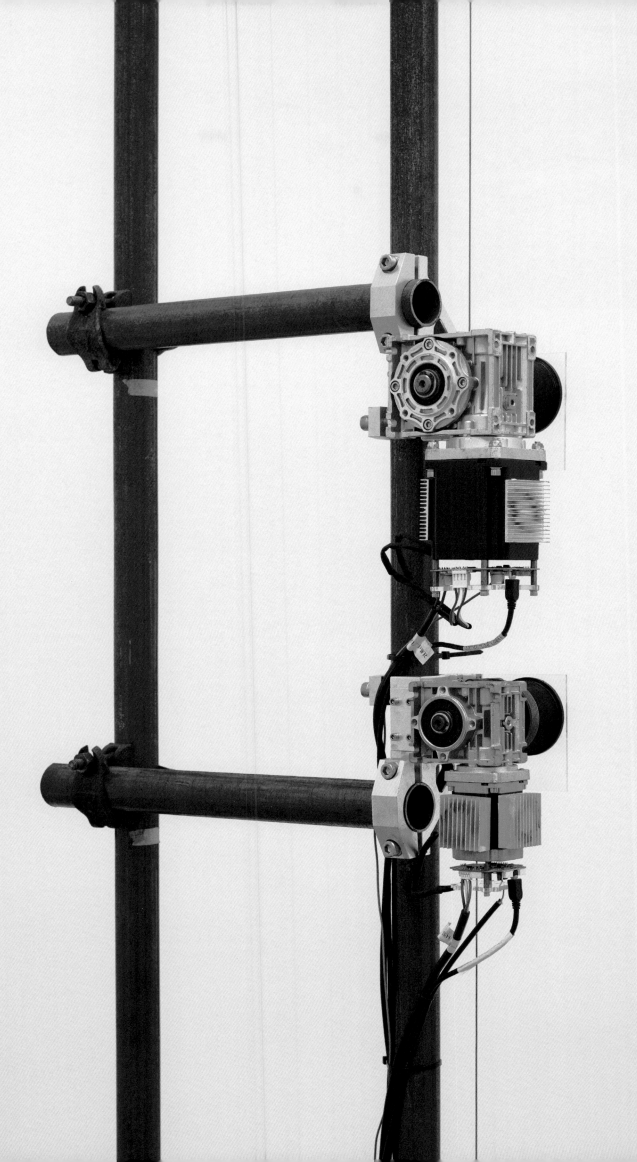

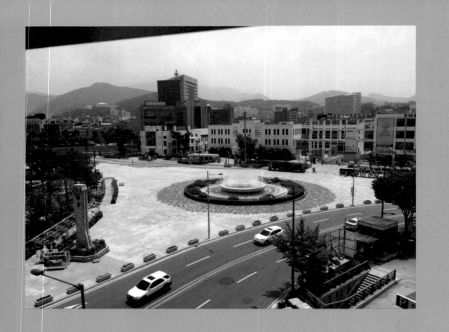

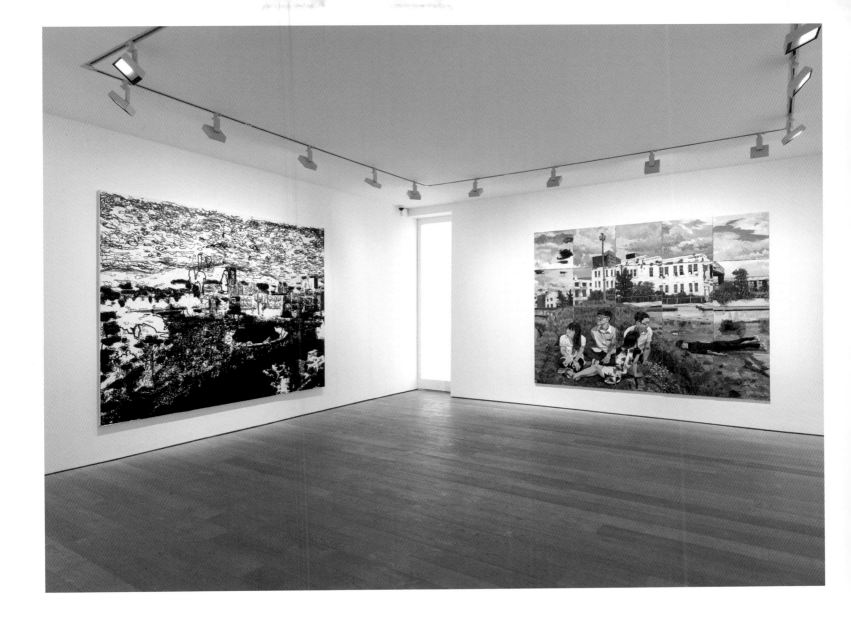

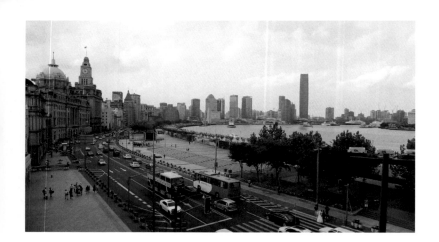

Mars black

x 3 | 6, 6, 18

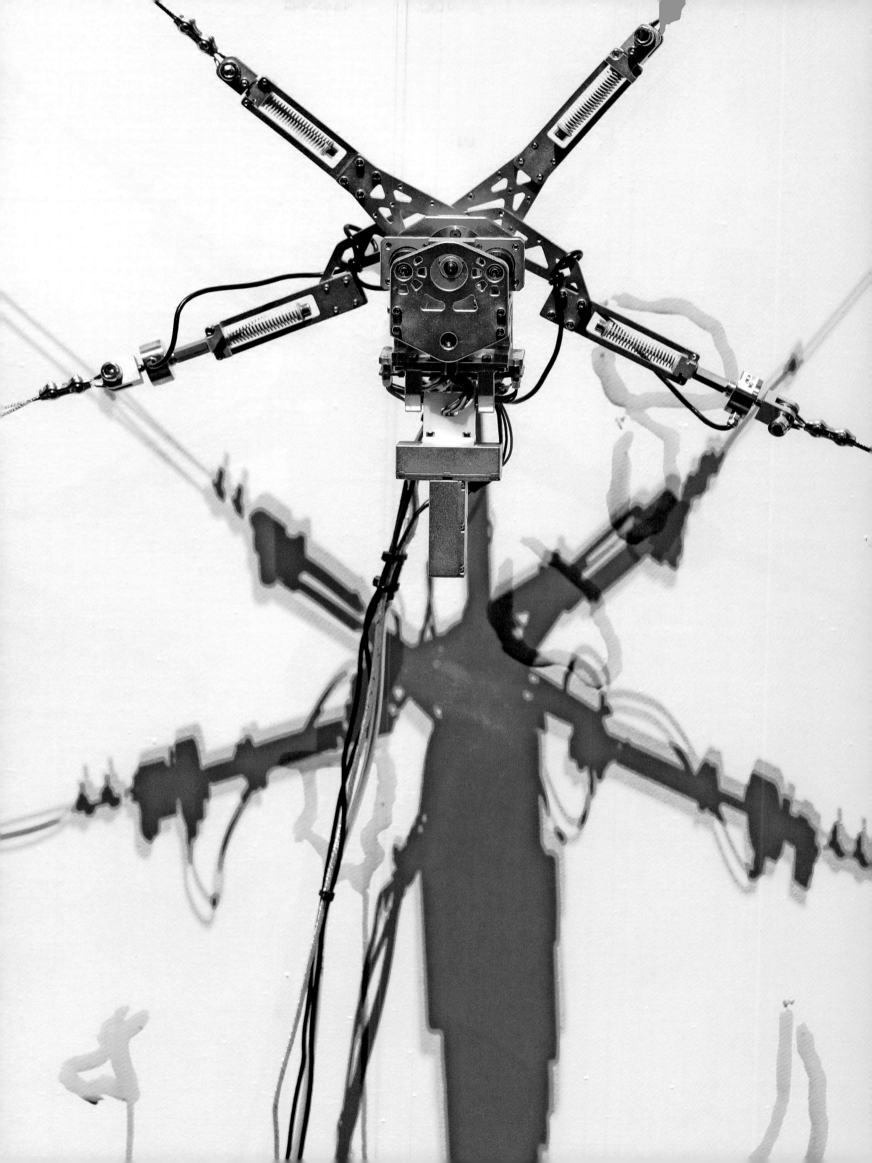

Permanent yellow
永固黄

Cadium yellow
镉黄

vermilion
朱红

16.6.19

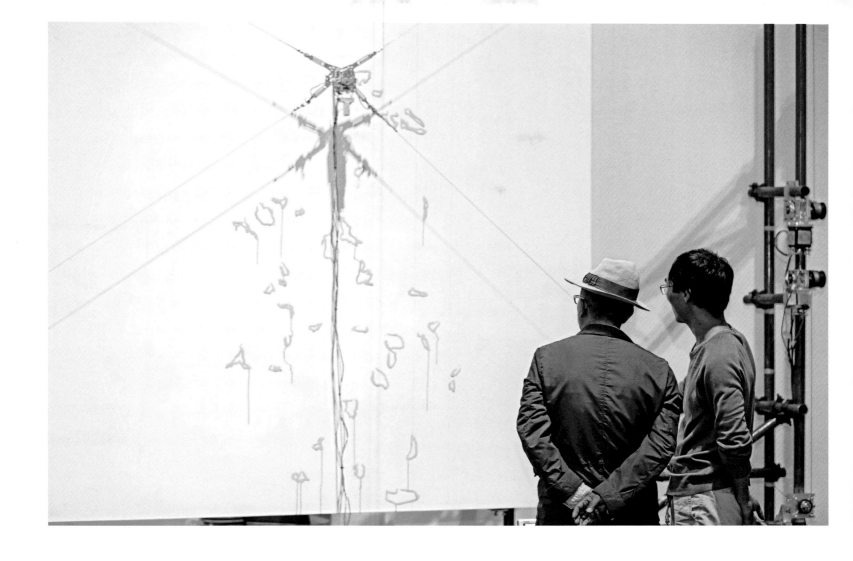

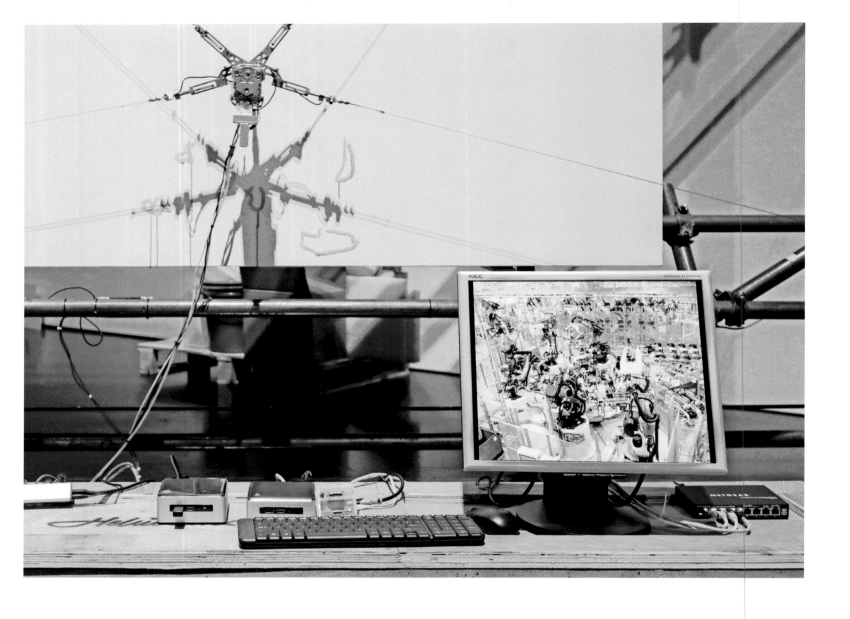

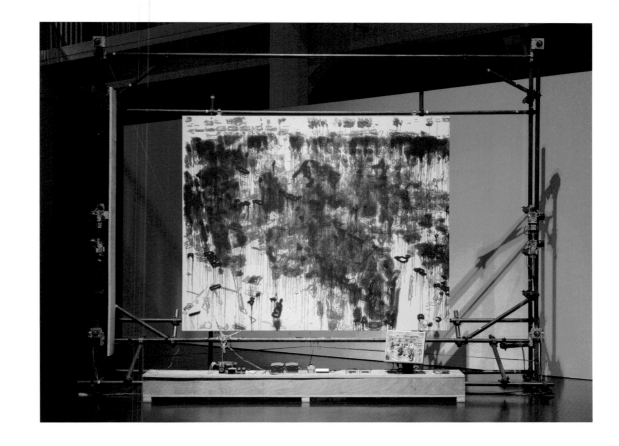

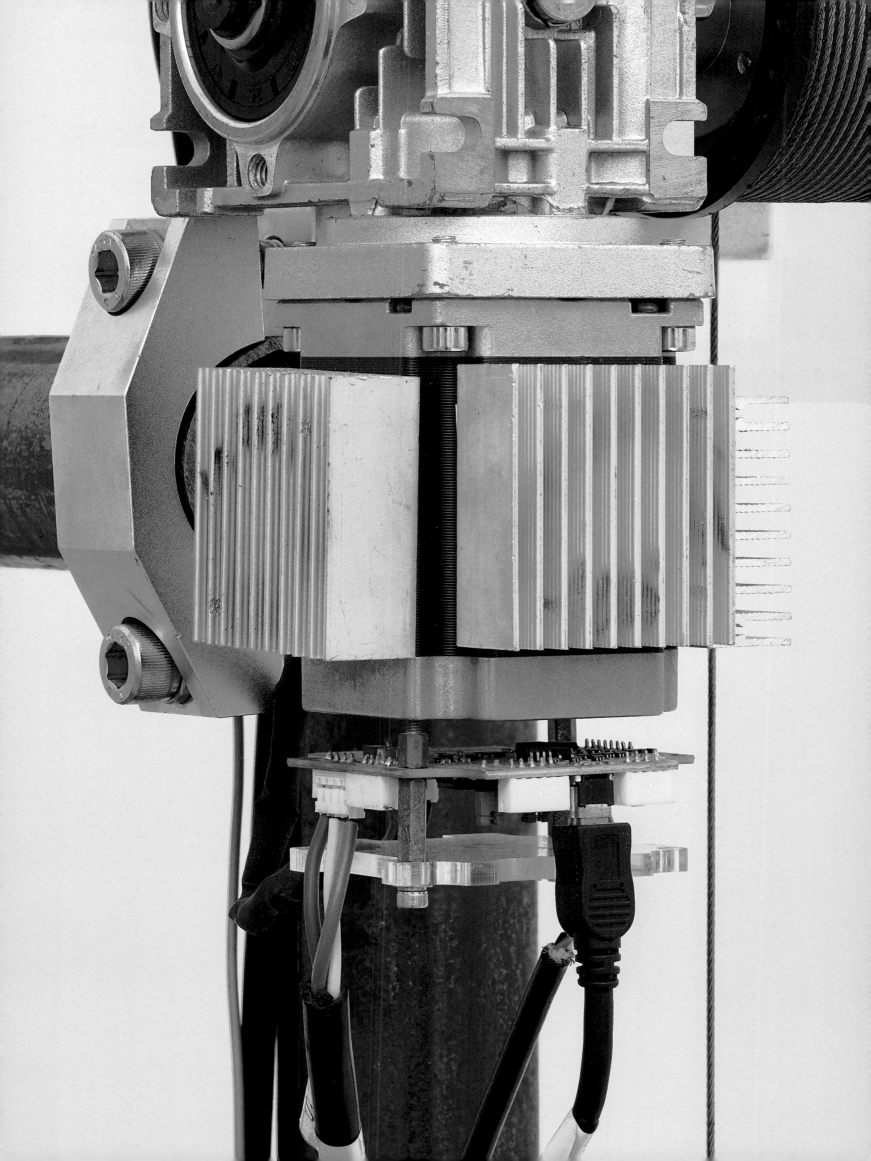

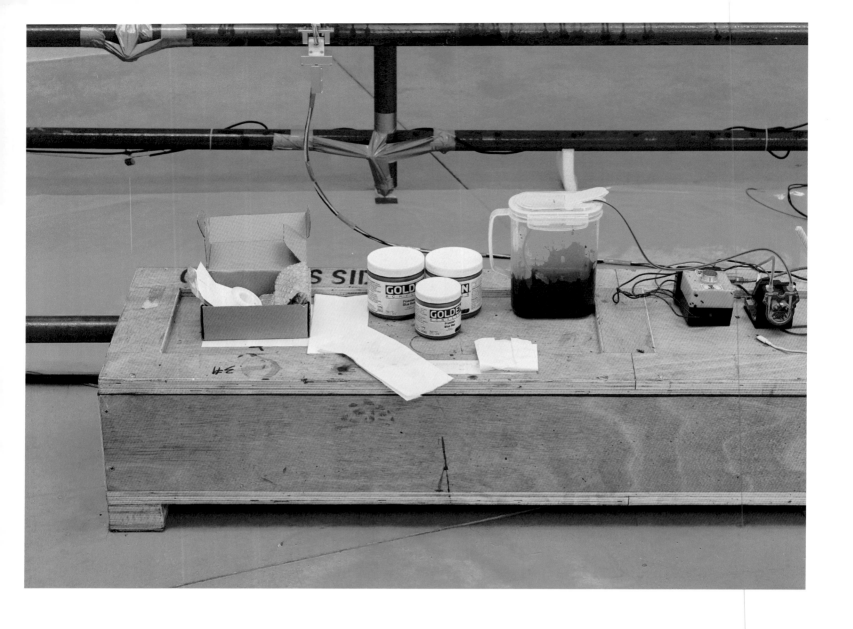

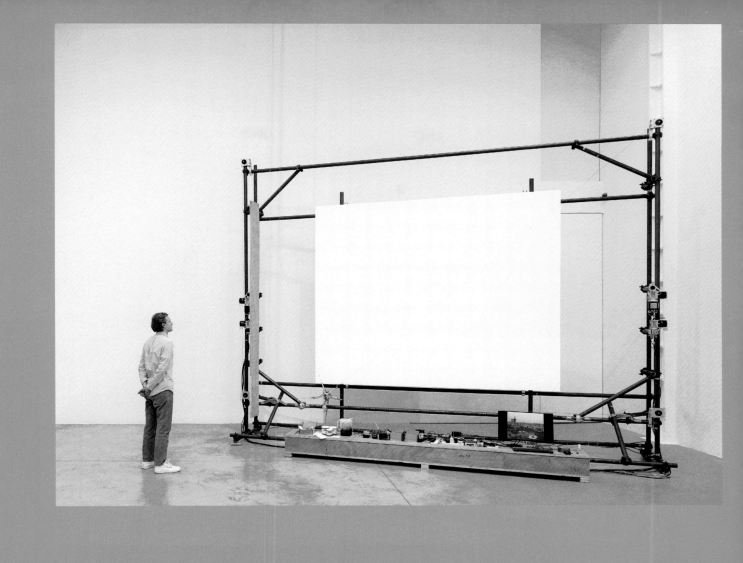

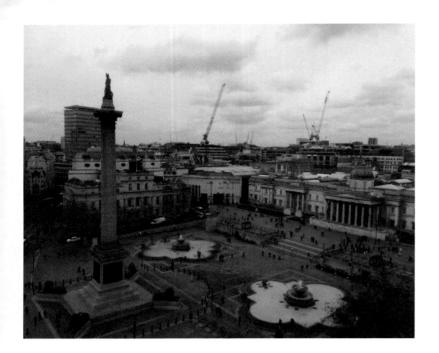

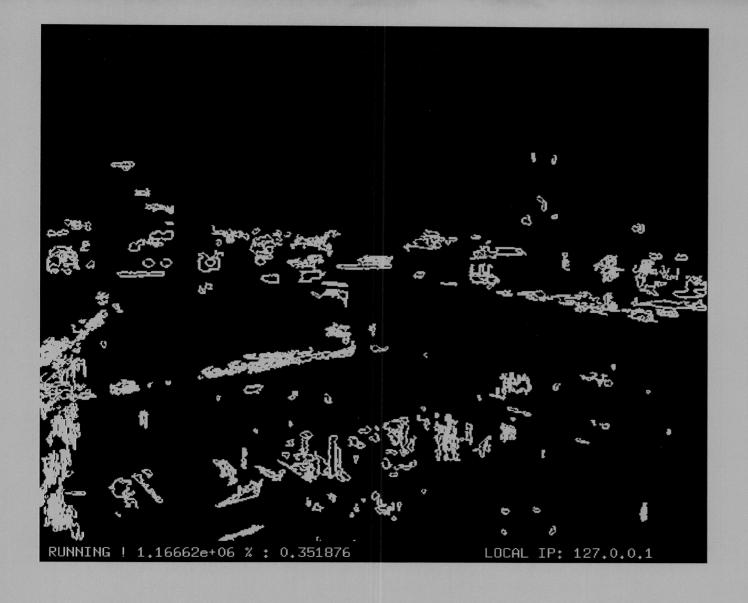

RUNNING ! 1.16662e+06 % : 0.351876 LOCAL IP: 127.0.0.1

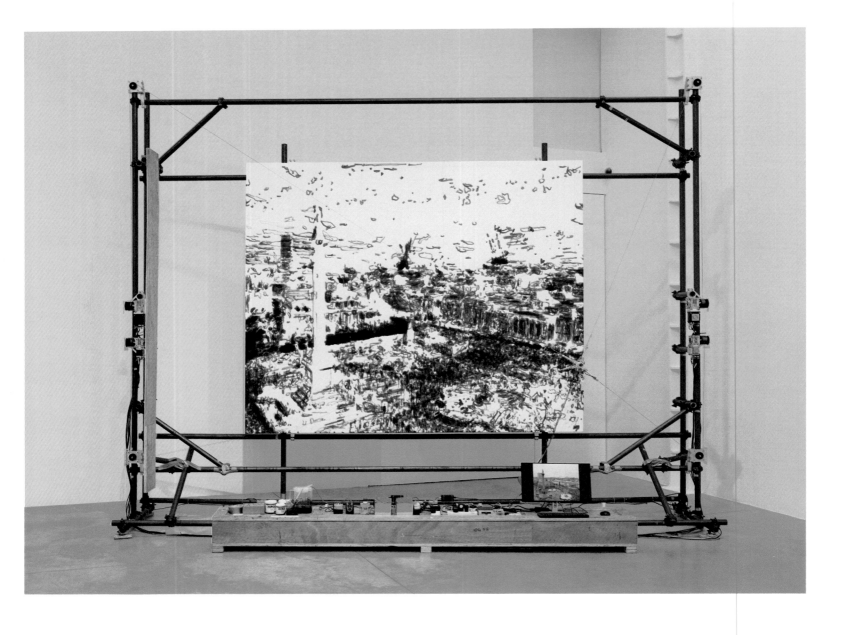

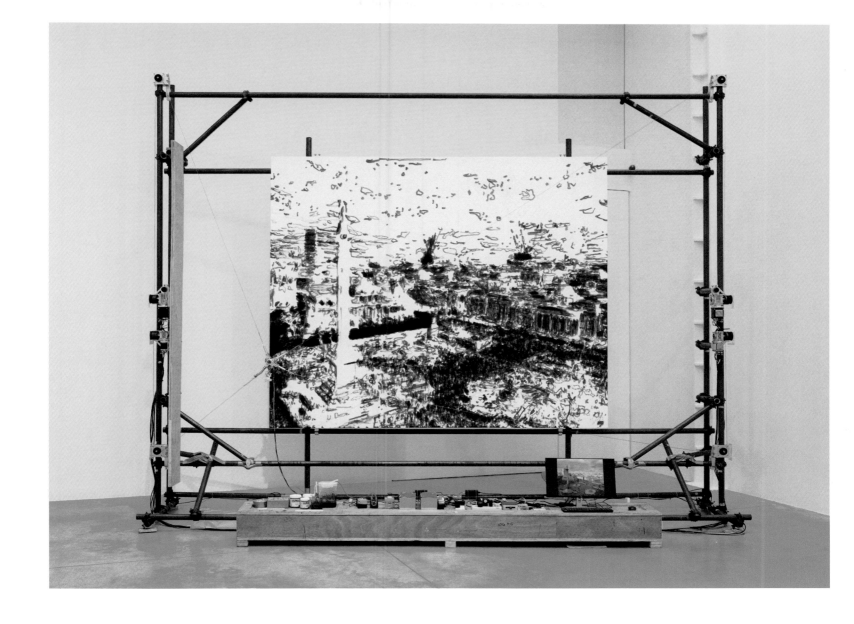

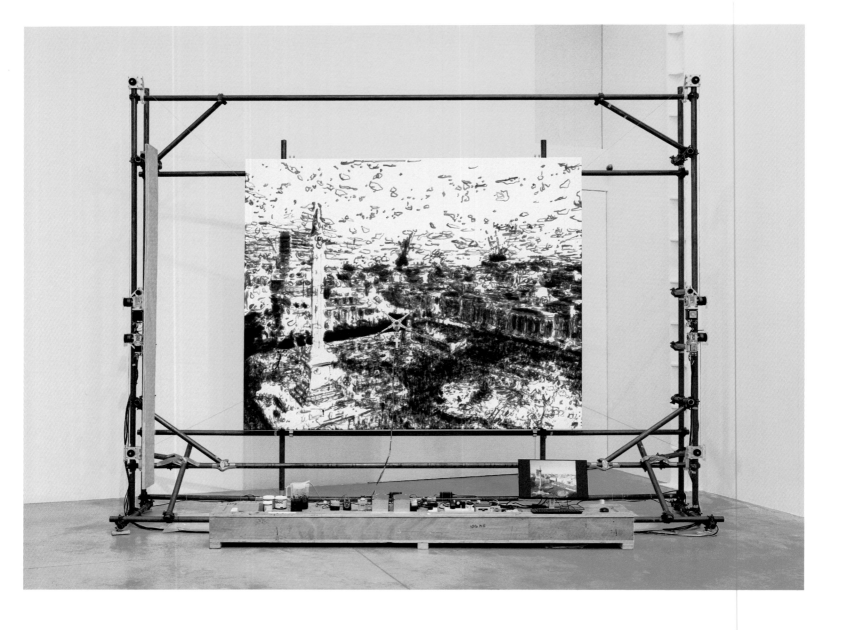

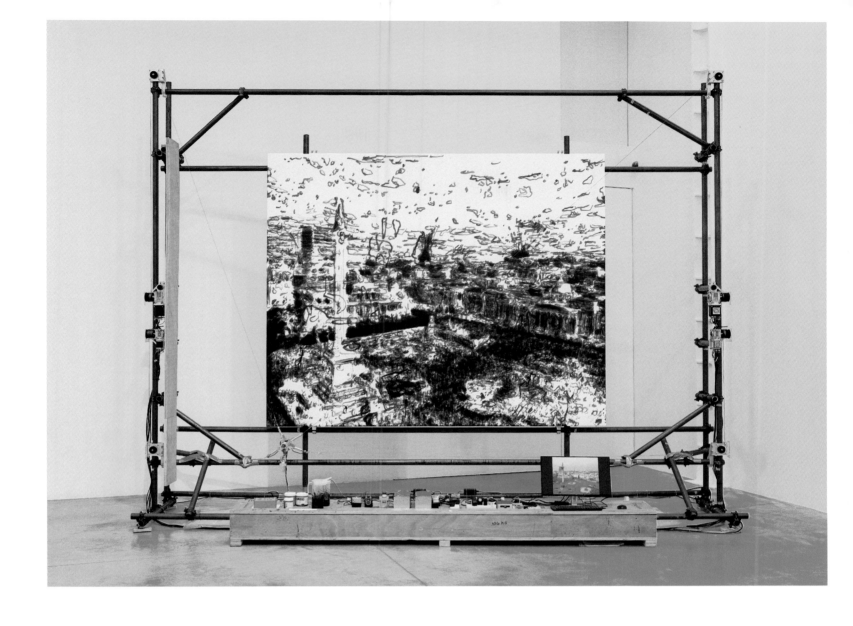

Weight of Insomnia (Beijing), 2016, acrylic on canvas, 250 × 300cm (98 ³⁄₈ × 118 ¹⁄₈ in)

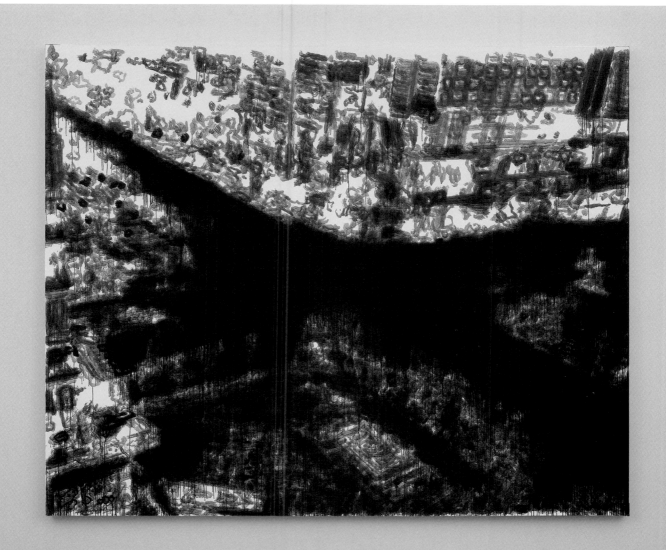

Weight of Insomnia (Shanghai), 2016, acrylic on canvas, 250 × 300cm (98 3/8 × 118 1/8 in)

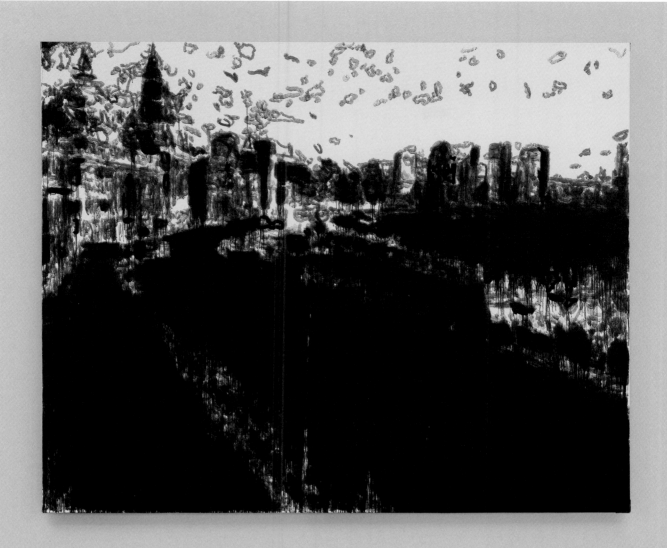

Weight of Insomnia (Jincheng), 2016, acrylic on canvas, 250 × 300cm (98 ⅜ × 118 ⅛ in)

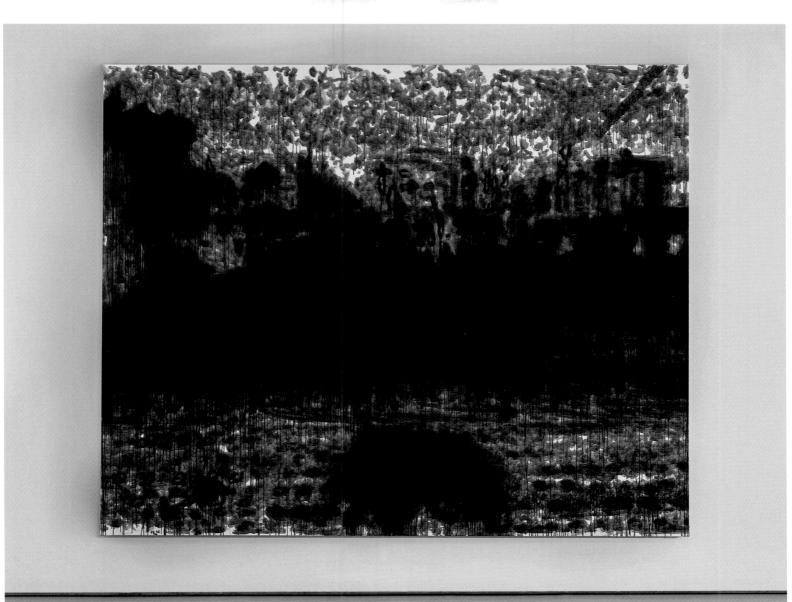

Weight of Insomnia (Karlsruhe), 2017-2018, acrylic on canvas, 250 × 300cm (98 3/8 × 118 1/8 in)

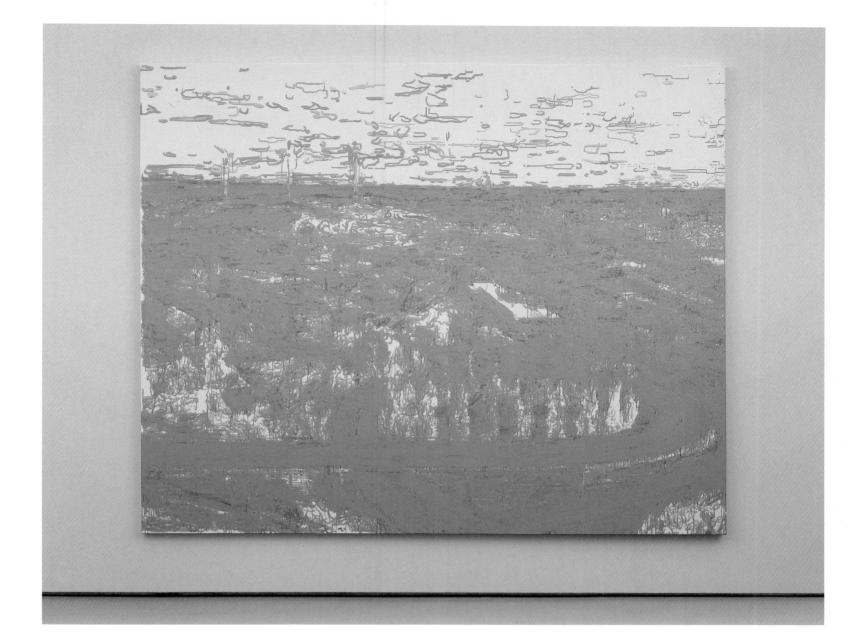

Weight of Insomnia (Berlin), 2017-2018, acrylic on canvas, 250×300cm (98⅜×118⅛ in)

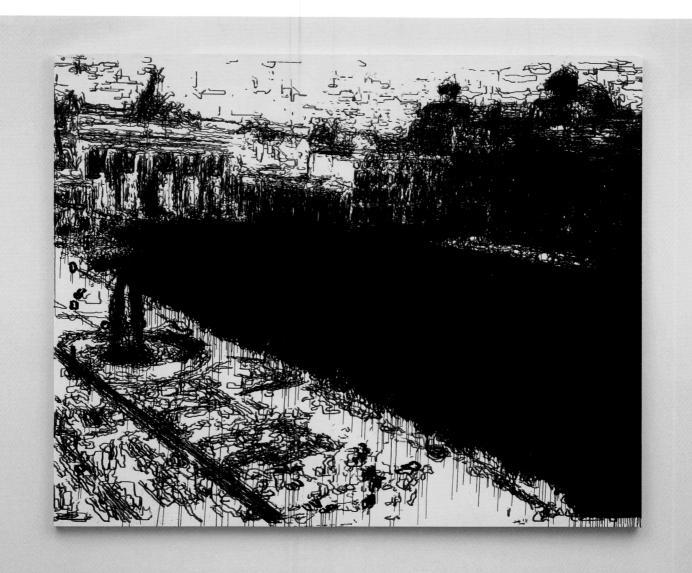

Weight of Insomnia (BMW Dingolfing), 2017-2018, acrylic on canvas, 250×300cm (98 3/8 × 118 1/8 in)

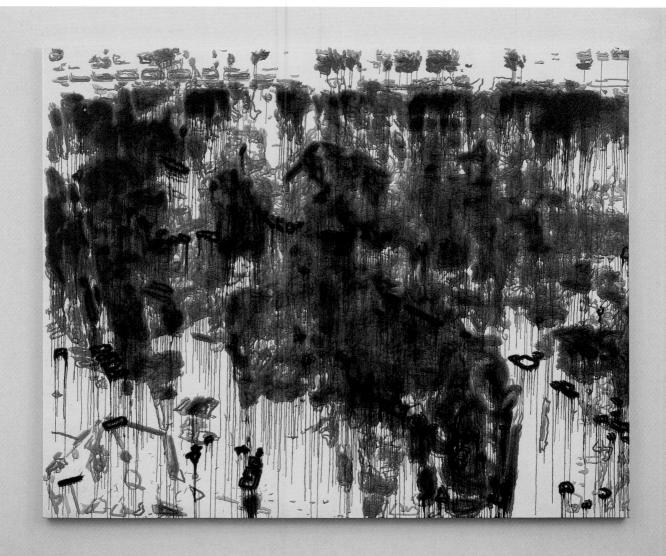

Weight of Insomnia (Sydney), 2018, acrylic on canvas, 200 × 240cm (78 ¾ × 94 ½ in)

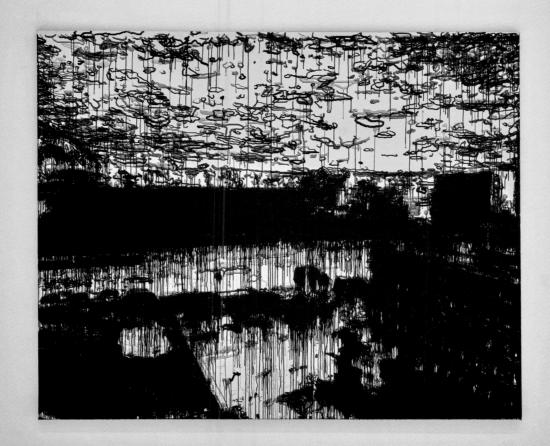

Weight of Insomnia (Oberkasseler Bridge, Düsseldorf), 2018, acrylic on canvas, 250 × 300cm (98 3/8 × 118 1/8 in)

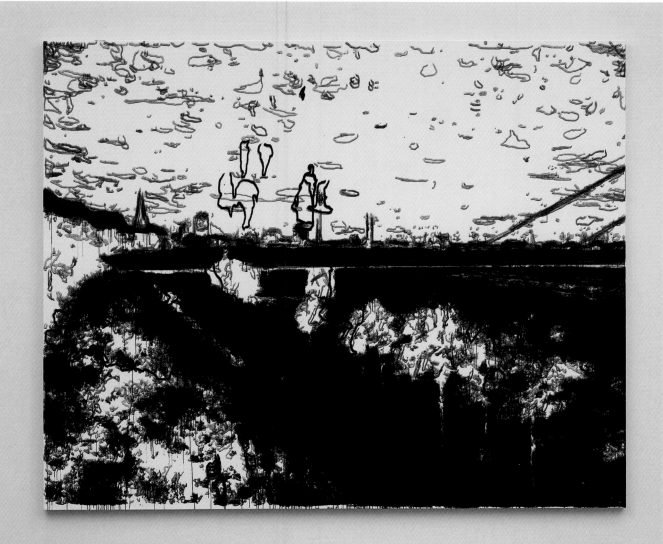

Weight of Insomnia (Seoul), 2018, acrylic on canvas, 240 × 300cm (94 ³⁄₈ × 118 ¹⁄₈ in)

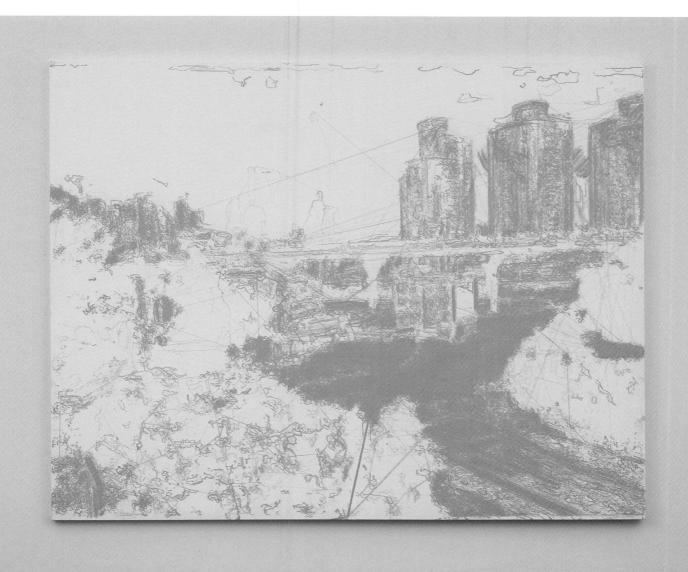

Weight of Insomnia (Gwangju), 2018, acrylic on canvas, 240 × 300cm (94⅜ × 118⅛ in)

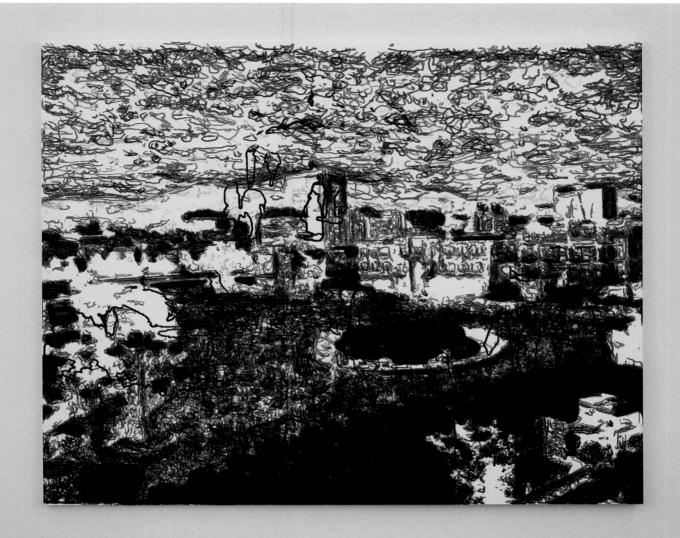

Weight of Insomnia (London), 2019, acrylic on canvas, 250 × 300cm (98 ³⁄₈ × 118 ¹⁄₈ in)

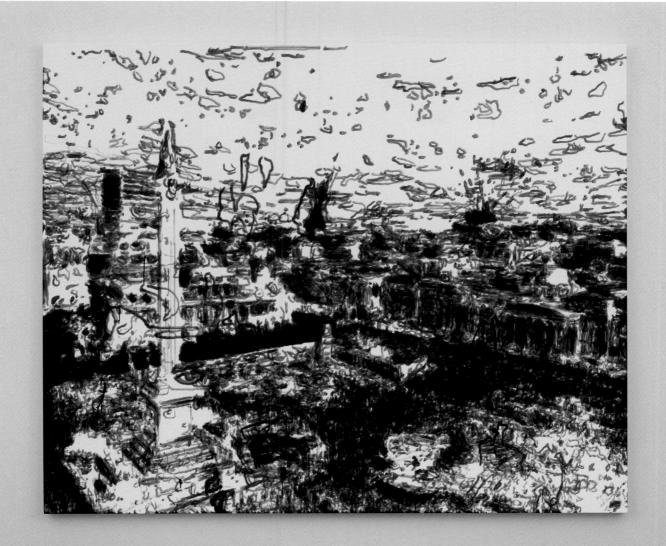

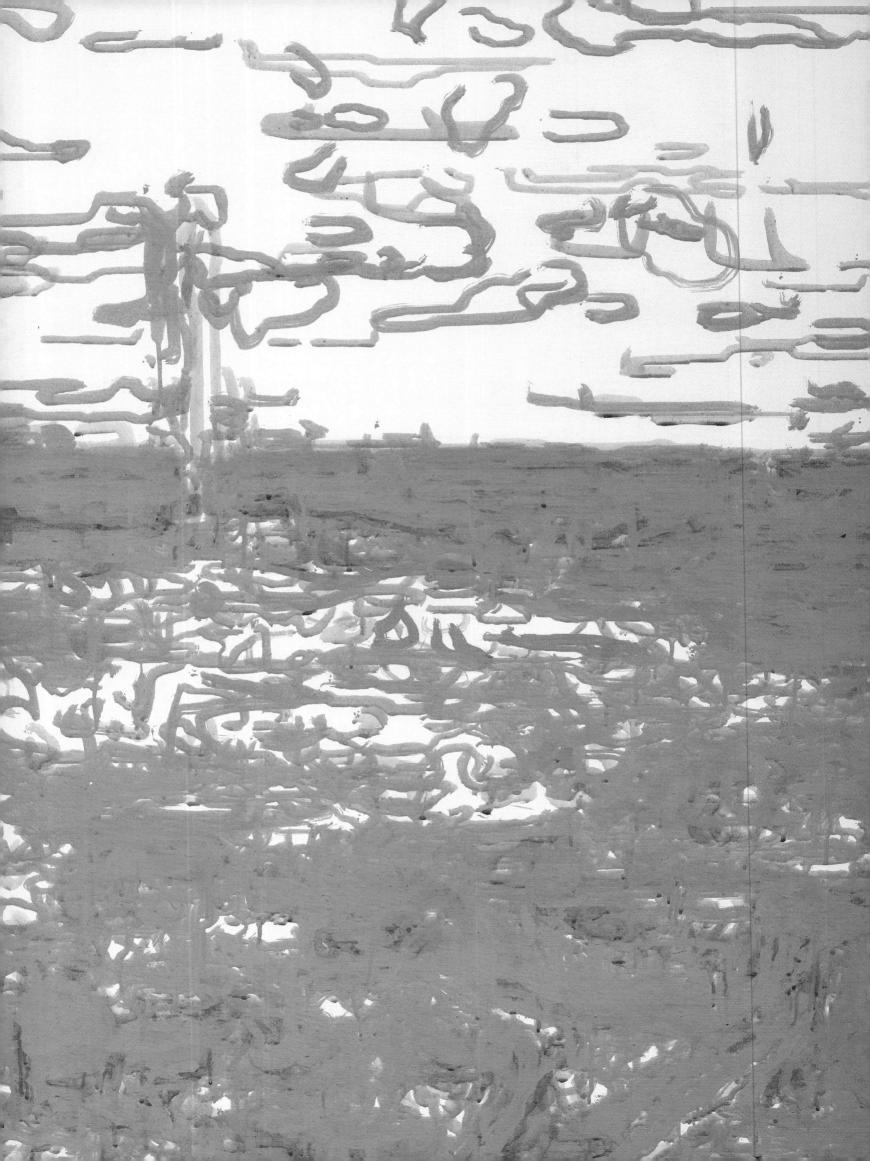

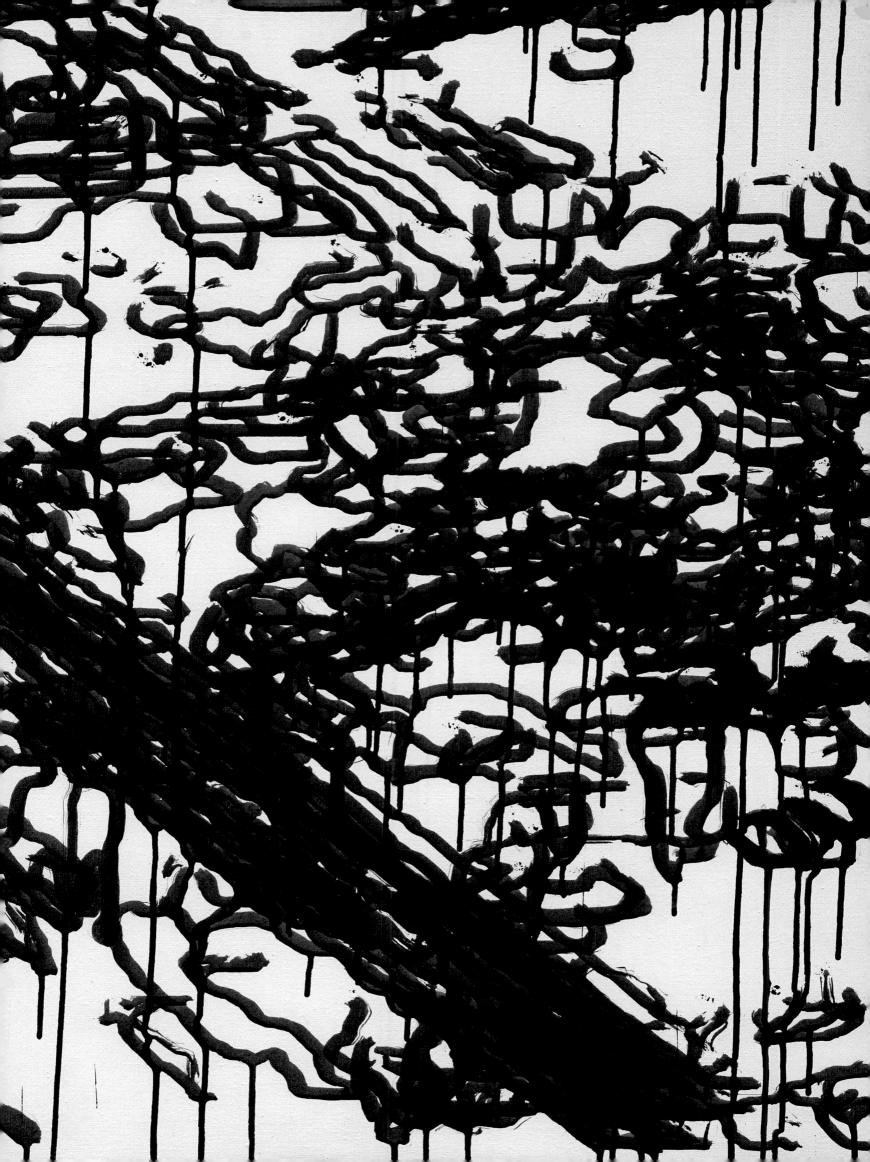

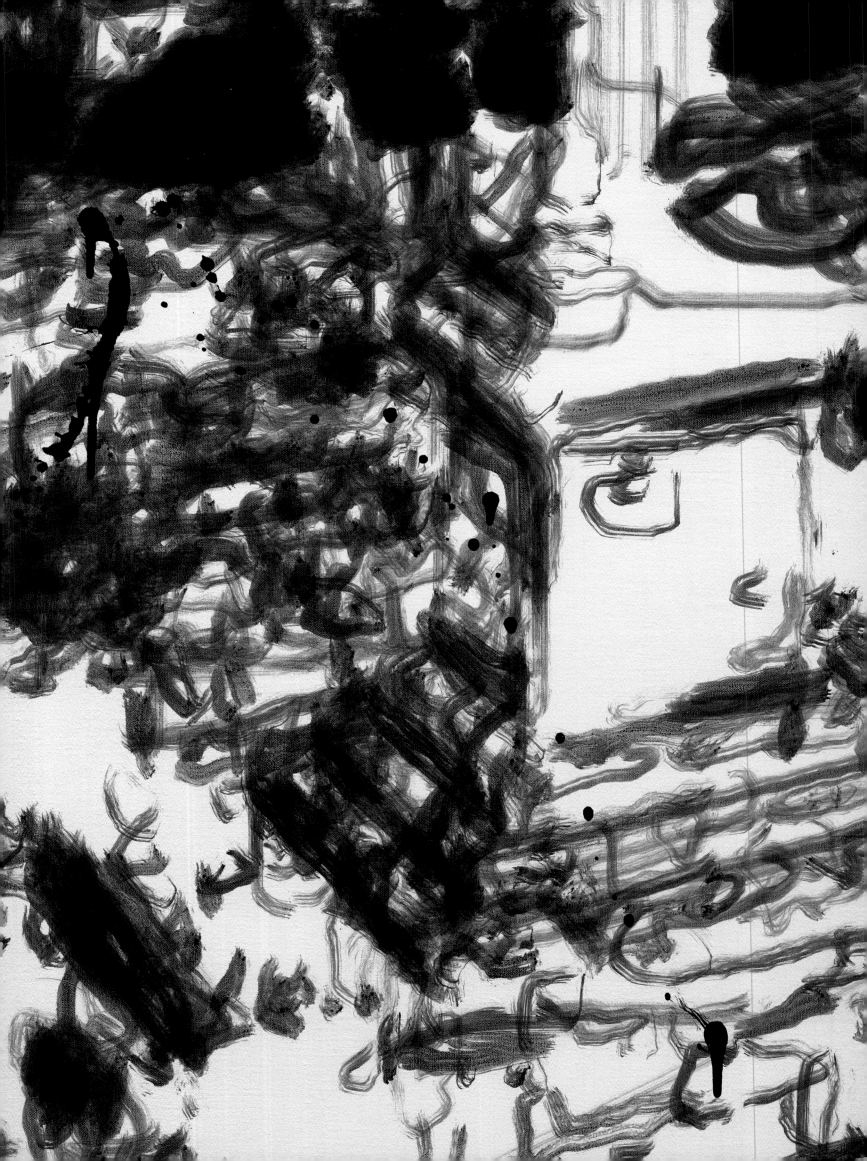

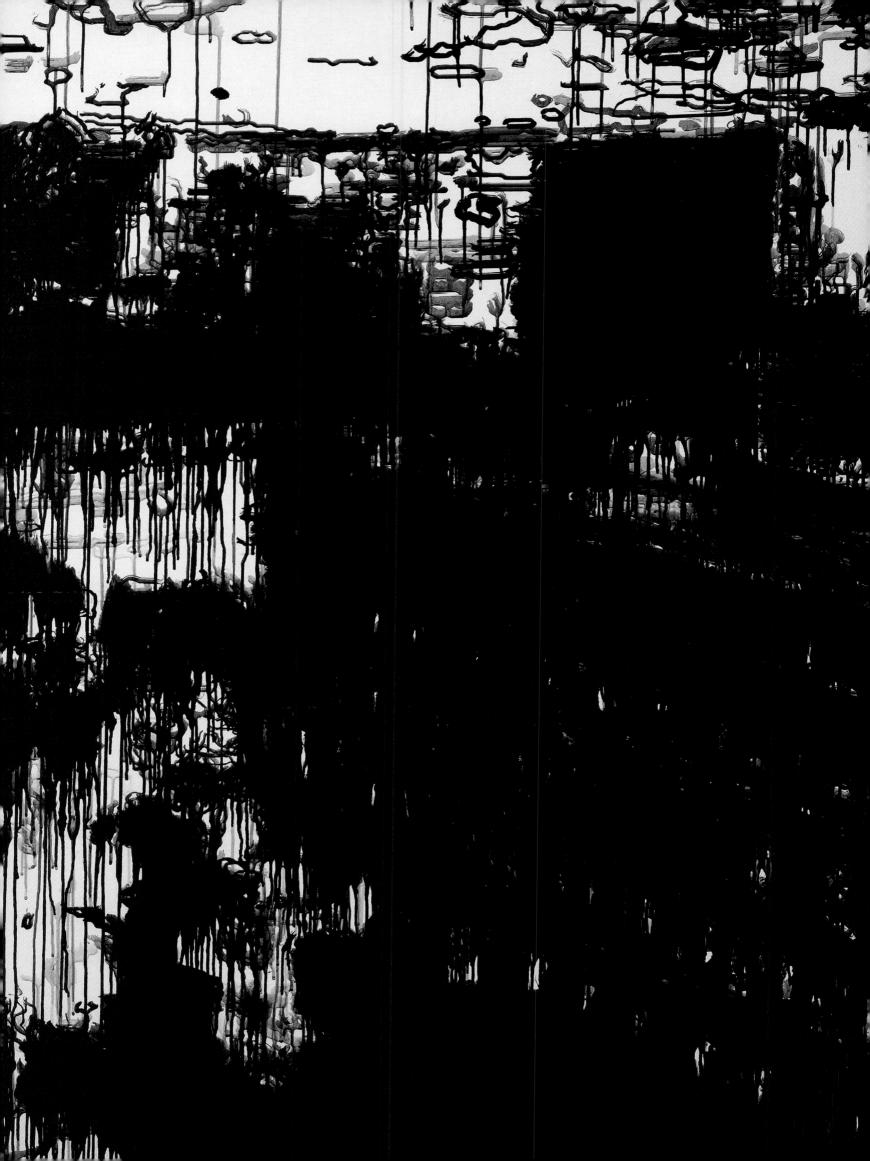

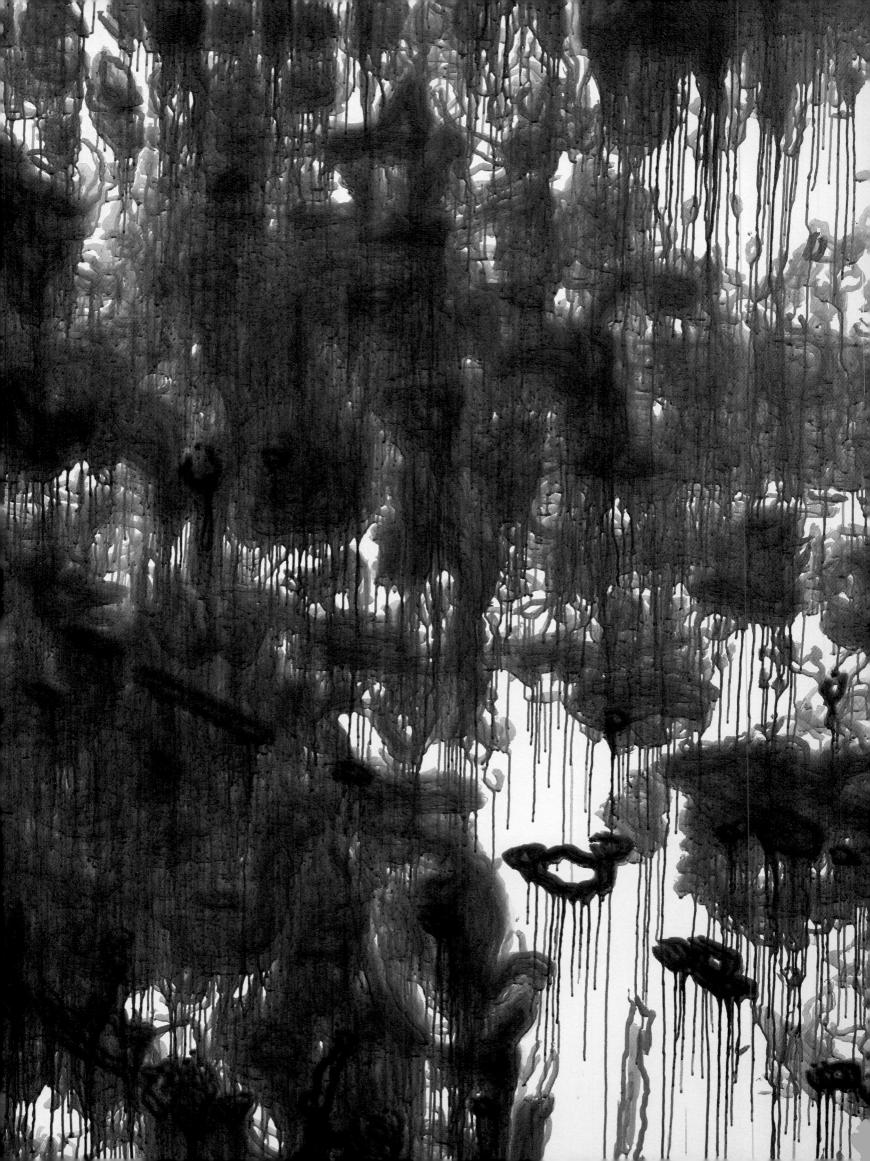

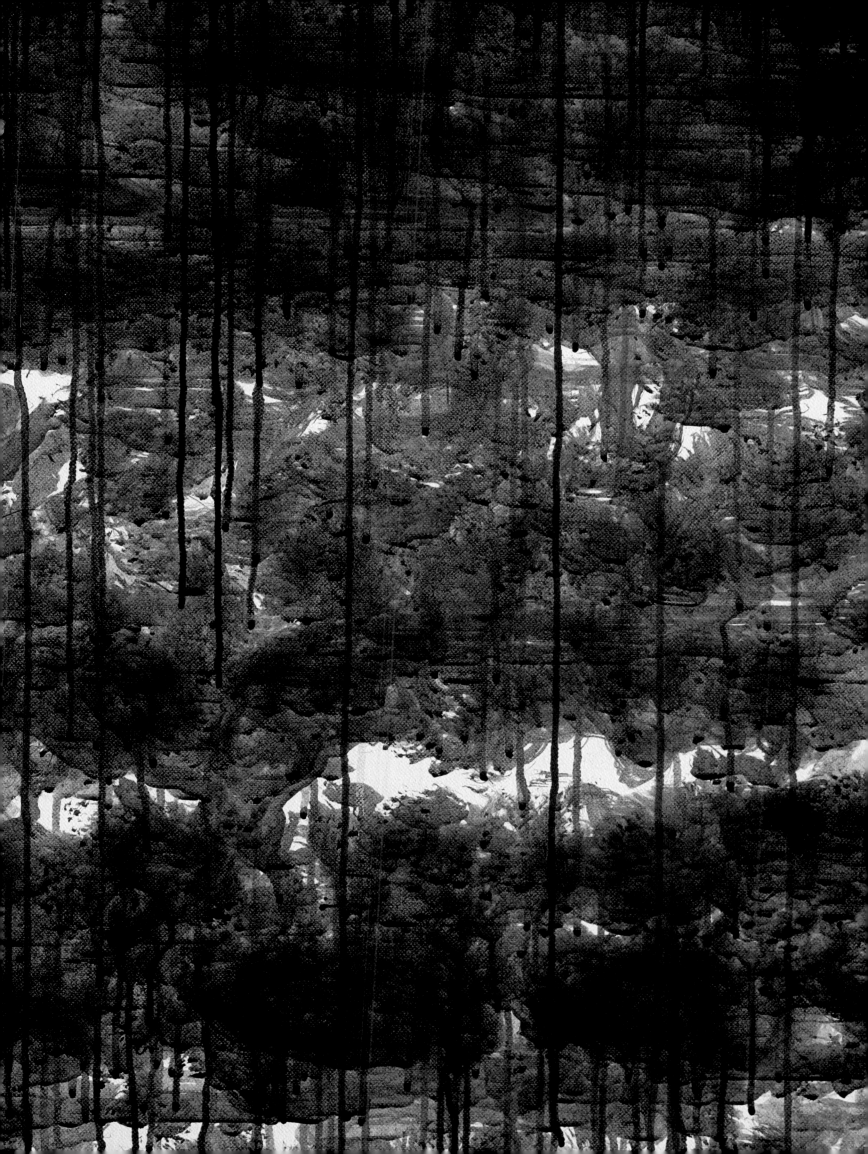

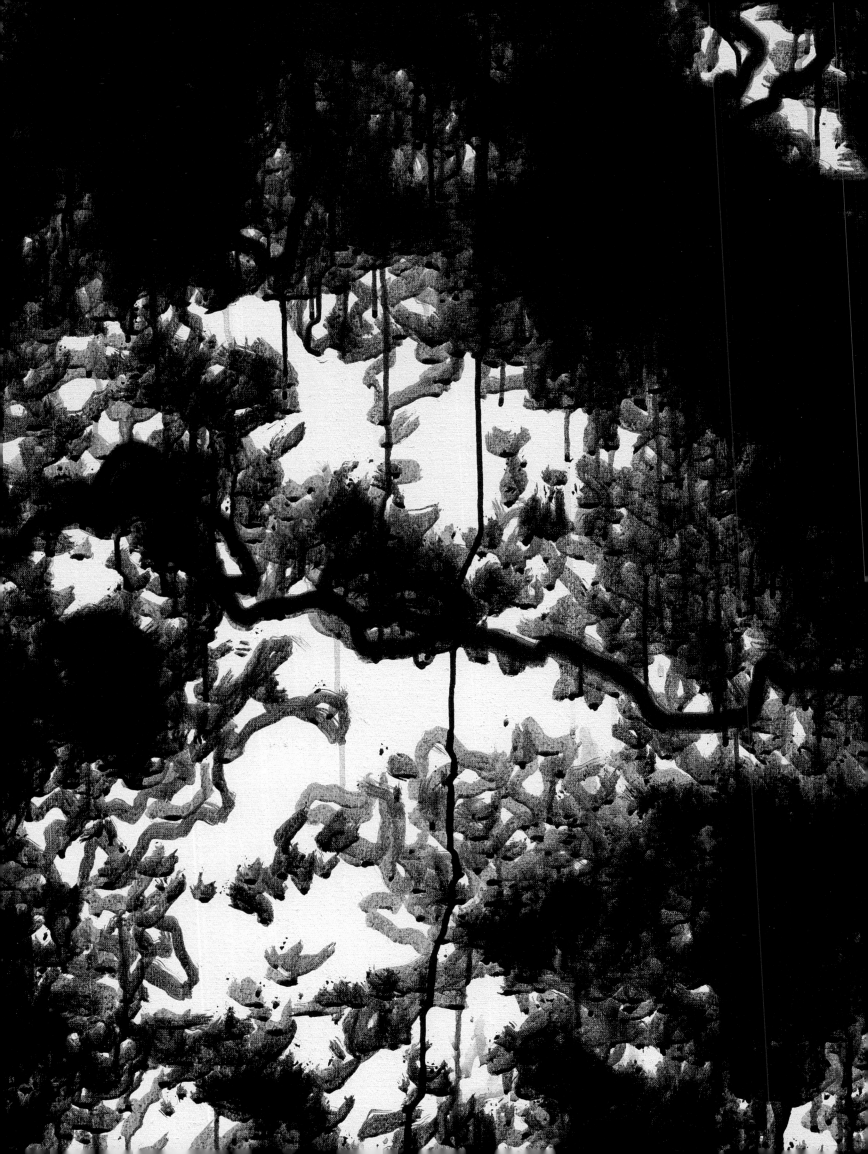

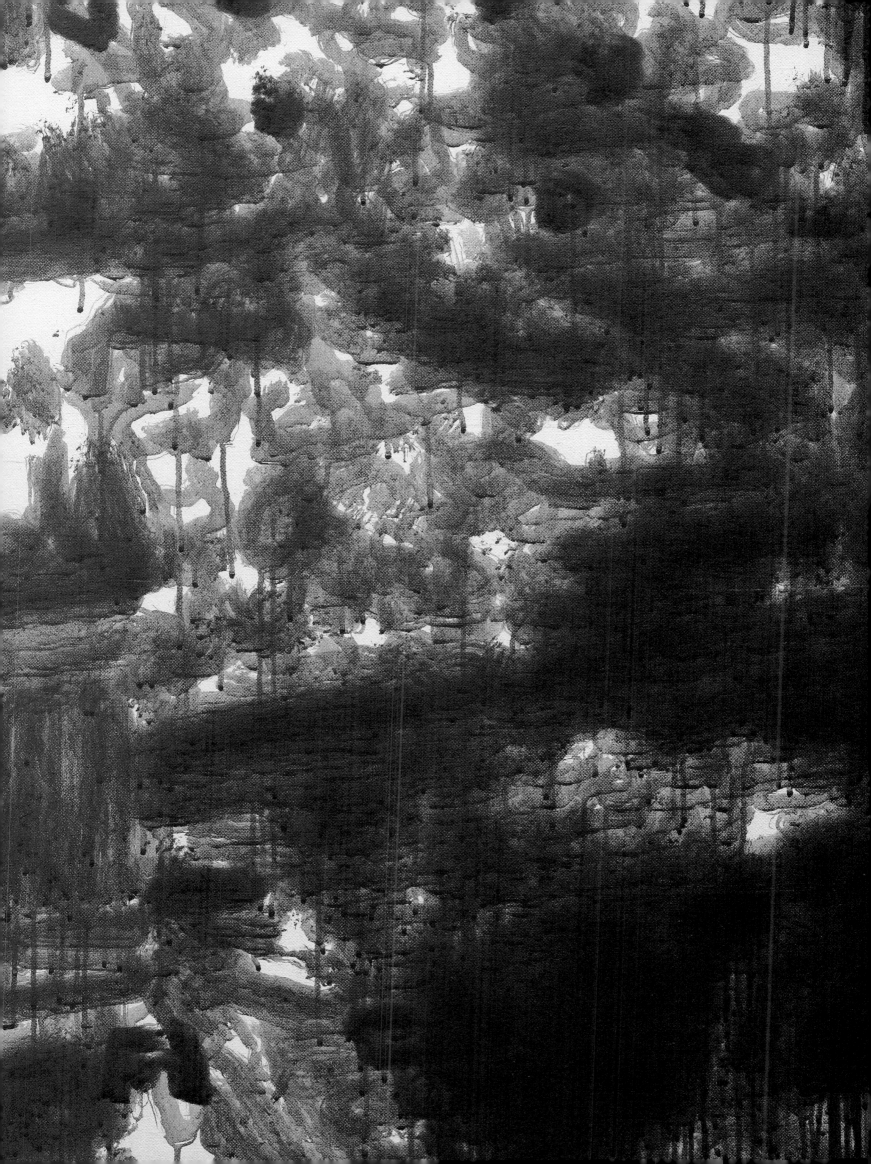

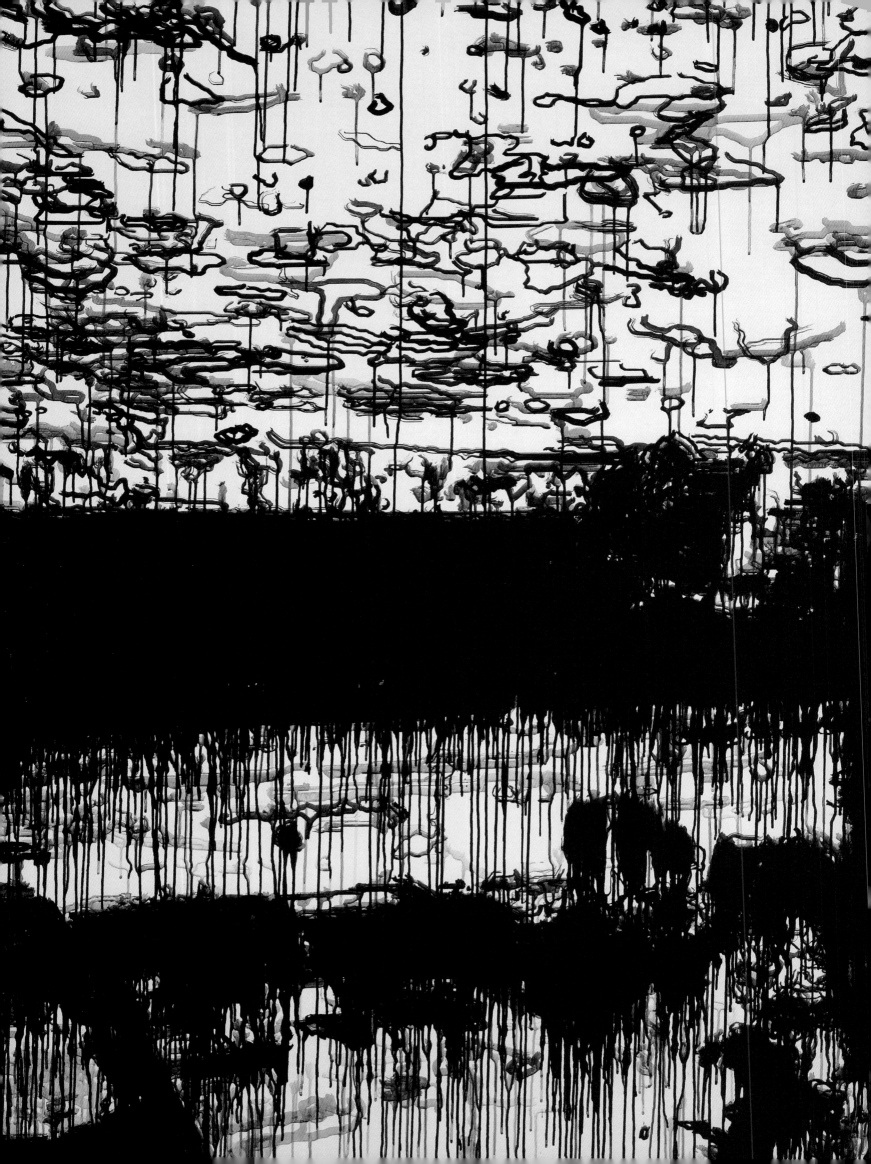

Liu Xiaodong is a painter of modern life, whose large-scale works serve as a kind of history painting for the emerging world. A leading figure among the Chinese Neo-Realist painters to emerge in the 1990s, his adherence to figurative painting amounts to a conceptual stance within a contemporary art context where photographic media dominates. While he works from life and *en plein air*, he chooses sitters to supply ancillary narratives to landscapes or situations locating the human dimension to global issues.

Since 2015, Liu has been working on this series of 21st-century landscape paintings, collectively entitled *Weight of Insomnia*, using robotic arms and surveillance cameras. The project was produced with the expertise the Research/Creation at the Chronus Art Center in Shanghai, where the first paintings appeared in a show curated by Liu's long-time collaborator and friend, Zhang Ga—after which it toured to ZKM Museum of Contemporary Art in Karlsruhe (2016) and the Nam June Paik Art Center in Seoul (2018). So far the painting machine has been trained on intersections and busy byways, capturing vehicles, pedestrians and changing weather conditions in cities such as Beijing, Shanghai, Jincheng, Gwangju, Berlin, Karlsruhe, Sydney and now from an iconic London location above Trafalgar Square.

Liu Xiaodong (b.1963) lives and works in Beijing. He has a BFA and an MFA in painting from the Central Academy of Fine Arts, Beijing (1988, 1995), where he now holds tenure as professor. He continued his studies at the Academy of Fine Arts, University of Complutense, Madrid, Spain (1998–1999). His work has been the subject of numerous solo exhibitions including Louisiana Museum of Modern Art, Humlebæk, Denmark (2019); NRW-Forum & Kunsthalle Düsseldorf, Germany (2018); Palazzo Strozzi, Florence, Italy (2016); Fondazione Giorgio Cini, Venice, Italy (2015); Shao Zhong Foundation Art Museum, Guangzhou, China (2014); Minsheng Museum, Shanghai, China (2014); Seattle Art Museum, WA, USA (2013); Today Art Museum, Beijing, China (2013); Kunsthaus Graz, Austria (2012); Xinjiang Arts Centre, Urumqi, China (2012); and Ullens Center for Contemporary Art, Beijing, China (2010). His work has been included in numerous group exhibitions including Gwangju Biennale (2014), Shanghai Biennale (2000, 2010), the 15th Biennale of Sydney (2006) and the Venice Biennale (2013, 1997).

策展人张尕受上海新时线媒体艺术中心委任，构思及策划一连串以「艺术与科技」为主题的项目，《失眠的重量》正是其中第一个得以实现的作品系列。此外，里森画廊及北京的中鸿创艺有限公司也有为作品提供资助。

《术问—真实的回归》是一个由张尕策展的巡回展览，而画作系列《失眠的重量》是其中一部份，曾在下列场地展出：中国北京的尤伦斯当代艺术中心（2019年）、南韩首尔的白南准艺术中心（2018年）、德国卡尔斯鲁厄的ZKM艺术与媒体中心（2017至2018年）及中国上海的新时线媒体艺术中心（2016年）。

2018年，澳洲悉尼的白兔基金会画廊于名为《当沉睡者觉醒》的团体展览中，特别委任刘小东展出作品《失眠的重量》。

同年，于德国杜塞尔多夫北威州论坛美术馆为刘小东筹办的个人回顾展《缓慢的归途》中，作品《失眠的重量》（杜塞尔多夫的奥培卡舍勒桥）亦有份参与。

特别鸣谢：北京三里屯CHAO、上海沪申画廊、PIGMENT、青远堂、宝马集团、北京的中鸿创艺有限公司、京畿文化基金会、歌德学院、斯特兰德一号、英国伦敦Metrus物业管理公司、白兔画廊及北京真场艺术科技有限公司。

里森画廊与刘小东在此衷心感谢各位 — 致 郭城、菲托·萨格雷拉、李轲、饶雪峰、李辉、李线毅、赵迎飞、陈成 、吕杰、郭朋、林家勒、张尕、Jeffery Sequeira、Marco Betelli、Dan Basenpt、Martin Lovejoy、Luise Guest、Judith Neilson、David Williams、Phil Ismay、Thomas Heyworth、Rute Ventura、Jamie Partridge、Scott Utting、Lucy Wilkinson和Greg Hilty。

Weight of Insomnia was the first edition of a series of projects under the auspices of Art & Technology conceived and curated by Zhang Ga, commissioned by Chronus Art Center, supported by Lisson Gallery and ZONHOM Cultural Development Co., Ltd.

The series were included in the exhibition 'Datumsoria', curated by Zhang Ga and presented at the following venues:

CAFA Art Museum, Beijing, China (2019),
Nam June Paik Art Center, Seoul, South Korea (2018),
ZKM Center for Art and Media, Karlsruhe, Germany (2017-2018),
Chronus Art Center (CAC), Shanghai, China (2016)

Weight of Insomnia (Sydney) was specially commissioned for the exhibition 'The Sleeper Awakes' at the White Rabbit Collection, Sydney, Australia (2018)

Weight of Insomnia (Oberkasseler Bridge, Düsseldorf) was commissioned for the exhibition 'Liu Xiaodong - Slow Homecoming' at NRW-Forum, Düsseldorf, Germany (2018)

Special thanks:
Beijing Sanlitun CHAO, Shanghai Gallery of Art, PIGMENT, Qingyuantang
EnBW, BMW Group, ZONHOM Cultural Development Co.,Ltd.
Gyeonggi Cultural Foundation, Goethe Institut
One Strand, Metrus Property Advisors
White Rabbit Collection
Real Field Art-Tech co. Ltd.

The artist and the gallery wish to thank the following individuals:
Guo Cheng, Fito Segrera, Li Ke, Roger Rao, Li Hui, Li Xiany, Zhao Yingfei, Chen Cheng, Rao Xuefeng,
LV Jie, Guo Peng, Nikita Lin, Zhang Ga, Jeffrey Sequeira, Marco Betelli, Dan Basenpt, Martin Lovejoy,
Luise Guest, Judith Neilson, David Williams, Phil Ismay, Thomas Heyworth, Rute Ventura,
Jamie Partridge, Scott Utting, Lucy Wilkinson and Greg Hilty.

First published in 2019 to mark the occasion of Liu Xiaodong: *Weight of Insomnia*
25 January – 2 March 2019

Lisson Gallery, 27 Lisson Street, London NW1 5BY
T +44 (0)20 7724 2739

Lisson Gallery catalogue 93
ISBN 978-0-947830-71-7

Distributed in the UK and Europe by: Cornerhouse Publications
HOME, 2 Tony Wilson Place, Manchester M15 4FN, England
www.cornerhousepublications.org

Distributed in North America by: Artbook | D.A.P.
75 Broad Street, Suite 360, New York, NY 10004
T 800-338-2665 orders@dapinc.com

Distributed in Japan by: twelvebooks
#401, 4-24-5 Yoyogi, Shibuya, Tokyo, 1510053 Japan
twelve-books.com

Photography: George Darrel
with exception of
Weight of Insomnia (Sydney) 2018; Courtesy White Rabbit Collection; Photography David Roche
Weight of Insomnia (Shanghai) 2016; Photography Yang Hao
Weight of Insomnia (Jincheng) 2016; Photography Zhang Hong

Process images: Courtesy Rao Xuefeng, Zhao Yingfei, Fito Segrera, Chronus Art Centre, ZKM Karlsruhe, Nam June Paik Centre

Essays images: Nam June Paik, The Rehabilitation of Genghis Khan; Courtesy Nam June Paik Art Centre

Weight of Insomnia (Berlin) 2017-2018; Courtesy Private Collection

Weight of Insomnia (Sydney) 2018; Courtesy White Rabbit Collection, Sydney, Australia

Copyright © Lisson Gallery 2019

Texts copyright © Karen Archey, James Bridle, Liu Xiaodong, Zhang Ga

Translations: Marco Bettelli, Jack Harris, Choya Hung

All artworks copyright © 2019 Liu Xiaodong

Edited by: Lucy Smith, Rute Ventura, Ossian Ward
Design and Production: Studio Bergini
Typeface: SimSun (ZHONGYI Electronic Co.)
Printed by: Musumeci
Process images colour profile: colorlibrary.ch

British Library Cataloguing-in-Publication Data
A catalogue record for this book is available from the British Library

All Rights Reserved. No part of this publication may be reproduced or transmitted in any form or by any means, electronic or mechanical, including photocopy, recording or any other information storage and retrieval system, without prior permission in writing from the publisher.

LISSON GALLERY